RED LADDER
THEATRE COMPANY

Red Ladder Theatre Company proudly presents

UGLY

Written by Emma Adams
Directed by Rod Dixon

Leeds

Supported by
**ARTS COUNCIL
ENGLAND**

ARTS COUNCIL
ENGLAND

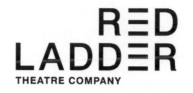

R=D
LADD=R
THEATRE COMPANY

"The anarchic energy of Rod Dixon's production provides a fine fit for the group's pranksterish outlook on life." The Guardian

Red Ladder is a national touring theatre company based at the Yorkshire Dance Centre, Leeds which has a national reputation and regularly tours the UK. Red Ladder is funded by Arts Council, Yorkshire and Leeds City Council.

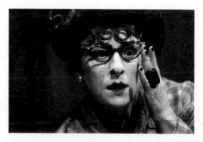

A radical theatre company with over 40 years of history behind us, we aim to make provocative theatre that contributes to social change and global justice.

Founded in 1968 in London, Red Ladder has a colourful history, rooted in the radical socialist theatre movement in Britain known as agitprop, via feminist theatre to the company's current position.

The company moved to Leeds in the 70's and is still based in the city. During the 80's the company redefined itself, changing its cooperative structure to a hierarchy and became a company that specialised in targeted work for specific youth audiences: Asian, Black, gender specific and deaf groups. The company founded the award winning Asian Theatre School in 1997.

Today the company is acknowledged as one of Britain's leading national touring companies; a producer of high quality new plays for diverse audiences, supports emerging artists and provides Global Justice advocacy for schools & community groups.

Red Ladder manages to reinvent itself without losing its fundamental aim of reaching parts other companies don't, won't or can't. David Edgar

Red Ladder productions: (Above) *Forgotten Things* by Emma Adams, (Below) *Where's Vietnam?* by Alice Nutter, photos by Tim Smith.

Productions for 2010 include: *Bittersweet Sunshine* by Ben Tagoe, for Emerge Festival, Leeds; *Ugly* by Emma Adams, National Tour, *Sex, Docks & Rock'n'Roll* by Boff Whalley, National Tour

Rod Dixon: Artistic Director
Chris Lloyd: Producer
Stefanie Gascoigne: Tour & Communication Manager
Jason Barker: Technical Assistant
Grace Cunnington: Global Justice Advocate
Jane Verity: Press & PR 07875 237925

Board of Directors:
Bernard Atha, Leeds City Councillor (Chair)
Nadine K Renton, Freelance artist, London
Peter Ward, Director, Hope Street Ltd, Liverpool
Rose Cuthbertson, Arts Consultant, Yorkshire
Emma Melling, Project Coordinator, Cartwheel Arts 'TUAO 2'
Teresa Brayshaw, Leeds Met University
Dan Jeffrey, Senior Manager, Bonner & Hindley Communications
Martyn Potter, Human Resources Consultant, PKR (UK)LLP

Red Ladder Theatre Company:
3, St Peter's Buildings, York Street, Leeds LS9 8AJ
tel: 0113 245 5311
fax: 0113 245 5351
www.redladder.co.uk
facebook:red ladder theatre company
twitter:redladdertheatr

THANK YOU TO THE ARTS COUNCIL AND LEEDS CITY COUNCIL FOR THEIR CONTINUING BELIEF & SUPPORT OF OUR WORK.

DEDICATED TO ALL THE ARTISTS WHO HAVE WORKED WITH RED LADDER PAST, PRESENT AND FUTURE...

Also thanks to Andrew Walby & James Illman at Oberon Books
Meg Davis at MBA Literary & Script Agents
Carriageworks Theatre, Leeds,
Andy Wood and Q Division – set builders
For Arden School at the College of Manchester for support and rehearsal space: Emma Kanis, Carole Courtney, David O'Shea
Amy Yardley – assisting Sara Perks
Chloe Plumb – Intern Fine Art Leeds Metropolitan University
RS Components for technical equipment
Barry Darnell (madebyanalogue) – design & artwork
Hair design and cuts by Piranha Hair Studio, Leeds (0113 243 2160)

THE COMPANY

Cast (in order of appearance)

Border Guard	Calum Clark
Woody	Rebecca Rogers
Ben	Peter Hinton
Mrs Mason	Jo Mousley
Mert	Anna-Maria Nabirye

Writer	Emma Adams
Director	Rod Dixon
Assistant Director	Plum Stupple-Harris
Set & Costume Design	Sara Perks
Sound Design	Jaydev Mistry
Lighting Design	Tim Skelly
Stage Management	Calum Clark
Assistant Technician	Jason Barker
Set Builders	Q Division

UGLY BY EMMA ADAMS - UK TOUR 2010

27/28 Sept – The Carriageworks
Leeds
www.carriageworkstheatre.org.uk
0113 224 3801

29 Sept – Stamford Arts Centre
www.stamfordartscentre.com
01780 763203

30 Sept – Guildhall Arts Centre
Grantham
www.guildhallartscentre.com
01476 406158

1 Oct – The Theatre Leatherhead
www.the-theatre.org
01372 365141

5 Oct – Square Chapel Centre for
the Arts Halifax
www.squarechapel.co.uk
01422 349422

6 Oct – The Castle Wellingborough
www.thecastle.org.uk
01933 270 007

7 Oct – The Civic Barnsley
www.barnsleycivic.co.uk
0845 180 0363

8 Oct – The Mart Theatre Skipton
www.themarttheatre.org.uk
01756 708011

11 Oct – Rose Theatre, Edge Hill
University, Ormskirk
www.edgehill.ac.uk/rosetheatre
01695 584480

12 Oct – Jacksons Lane London
www.jacksonslane.org.uk
020 8341 4421

14 Oct – the forum Barrow
www.theforumbarrow.co.uk
01229 820000

19 Oct – Bishops Greaves Theatre
Lincoln
www.bishopg.ac.uk/theatre
01522 583761

20 Oct – Riverhead Theatre Louth
www.louthplaygoers.co.uk
01507 600350

21 Oct – Lakeside Theatre
Colchester
www.essex.ac.uk/artson5
01206 873288

22 Oct – The Studio@TPS Petersfield
www.thestudiotps.com
01730 234641

24 Oct – Pavilion Arts Centre Studio
Buxton
www.buxtonoperahouse.org.uk
0845 1272190

1/2 Nov – Crucible Studio Theatre
Sheffield
www.sheffieldtheatres.co.uk
0114 249 6000

4 Nov – Octagon Theatre Bolton
www.octagonbolton.co.uk
01204 520661

CALUM CLARK
(Border Guard)

Clark, Calum, half special or almost special (status pending). BA in The Finest of Arts. Present research: Plagiarizing 20th century dystopian literature. Quote of the moment:

"What man has joined, nature is powerless to put asunder."

Calum returns to the team as Stage Manager/Actor having previously worked on *Forgotten Things* by Emma Adams, *Riot Rebellion & Bloody Insurrection* by Boff Whalley & Dom Grace, *Where's Vietnam?* by Alice Nutter and *Doors* by Madani Younis
A self proclaimed Jack Of All Trades, he co founded Liverpool stilt walking street theatre troupe Artemis in 2001and freelances as a performer, sound designer and multi-instrumentalist. He has been company stage manager with Red Ladder Theatre Company since 2007.

REBECCA ROGERS
(Woody)

Rebecca graduated from Bretton Hall in 2007, before joining Altitude North Theatre Company, and touring amphitheatres in Cyprus with Sophocles' *Ajax*. Since then she has worked with the Saltmine Theatre Company as an actor and director, performing in the UK and Lebanon. Rebecca has worked extensively with TaPRA (Theatre and Performance Research Association) in conjunction with The British Grotowski Project, and workshopped with physical theatre companies such as Theatre ad Infinitum and N.I.E. She also enjoys Clowning, and has worked with John Wright, which has enabled her to create and devise clowning and ensemble based pieces with Saltmine Theatre Company.

Rebecca believes Emma Adams' cleverly sculpted satire is undeniably provoking. It asks questions of us that we are too scared to contemplate because we are overwhelmed by the responsibility we fear may come with the answers. *UGLY* is not just a dark vision of the future, it also acts as a stark warning to all of us about the unsustainable consumerism of western society. The play turns international politics on its head, forcing us to stare into the face of inconvenient, non-conformist, often deemed ugly answers to our problems. Dare we believe that true strength lies in vulnerability? As Alex Vondette once put it, "Forget about making poverty history - climate change will make poverty permanent." *Ugly* is her first credit working for Red Ladder.

PETE HINTON
(Ben)

Personally, I believe that the choices we all face and make through life can usually be decided upon then and there as we are making them; we know in our guts whether our actions feel likely to leave a positive or negative effect on the recipient or receiver - or if morally - on the "bigger picture" be that the universe or God. Either way, as we make all those little decisions throughout each day; whether to recycle, whether to walk instead of get the bus, whether to catch the train instead of fly, whether to buy fair-trade or to save money and not, even the choice between buying a Big Mac or a Whopper - we forget

that bigger picture. We have become so indoctrinated, so conditioned by the systems of capitalism within which we are enslaved, we live our lives in ignorance, forgetting to stop and ask why things are as they are and are remaining so.

Have you ever stopped to ask yourself why, you are forced to live in a society where as of April 2010, despite 7.8% of the UK population (that's 2.47 million people) being unemployed, investment bankers' bonuses alone totalled £8.5bn in the same quarter? That figure of course not including the average going basic salary of a good investment banker on £100,000 a year...

If something doesn't crack and we as a materialistic society continue to consume relentlessly - regardless of the warnings and implications - I believe the world created within Ugly is more than just a plausible future. It is impossible to accept the play's given circumstances without inevitably having to ask those difficult questions, which we as individuals seem to be constantly ignoring: where does this fixation we all seem to have with The Extra Super Special people come from...?

Peter gained a BA in Acting from The Central School of Speech and Drama in 2006. Since drama school, his acting credits have included a walk-on-have-sex-walk-off part in *Hotel Babylon* (Ep1, Season 2), *King Lear* and *The Seagull* (Stratford-upon-Avon, World Tour, West End & a film - all for the RSC), *The Revenger's Tragedy* (National Theatre) and *Cyrano de Bergerac* (Chichester Festival Theatre). In between acting jobs he has also tried his hand at producing and directing. In March 2010 he completed an hour long TV show called The Academy, a mockumentary set in the Clapham Academy of Creative Art (CACA); a fictional, struggling drama school. The film is yet to be broadcast. When not acting Peter has had first hand experience of chasing the western capitalist dream,

even sinking so low as to pay the rent by working in IT. *Ugly* is his first credit working for Red Ladder.

JO MOUSLEY (Mrs Mason)

We are all special.

Jo has found 'The world of *Ugly*' a difficult imaginary journey to go on. The facts and figures are easily accessible, but to use them in the creation of a possible future environment forces you to accept the inevitable. Jo believes in James Lovelock's Gaia Hypothesis, a brave and independent scientist with a genuine love and understanding for the world in which he lives.

Ugly has so many huge questions within it, to start asking them is what makes this play important.

This is Jo's third production with Red Ladder, previously playing Lilly in *Forgotten Things* and Elsie in *Riot Rebellion and Bloody Insurrection*. Recent theatre includes; *The Road to Nab End* (Oldham Coliseum) *Blood Wedding* (Liverpool Playhouse) *Saturday Night, Sunday Morning* (Oldham Coliseum and Harrogate Theatre) *Jo in A Taste of Honey* (Lyric Theatre, Lowry Centre). TV; *Nice Guy Eddie* (BBC) *Coronation Street* (ITV) and *Emmerdale* (YTV)

ANNA-MARIE NABIRYE (Mert)

I often mix my politics and work and I'm very excited to be doing this with *Ugly* and Red Ladder. The environment is an issue that affects us all and the future of our children and their children. Like myself many of us are aware

of the dangers and problems facing us but feel paralysed by the enormity of it. I've found my way to stand up and make a difference through theatre hopefully by watching this play others will too.

Anna-Maria graduated from Mountview in 2006. Previously training at The Brit School for two years on the Acting Course. This introduction to the performing arts has provided Anna-Maria with a strong diversity of skills in movement, physical theatre, ensemble and contemporary theatre methods of working.

Other work I've been involved in includes *I Am A Warehouse* - Brighton Theatre, *The Rake's Return* - Matthew Townshend Productions, *Three Good Wives* - Little Angel Theatre, *Handa's Hen* - Little Angel Theatre, *A Place at The Table* - Daedalus, *A Memory, A Monologue, A Rant and A Prayer* - The New Players Theatre, *The Jew of Malta* - The Hall For Cornwall, *Igloo Hulabaloo & Icicle Bicycle* - Halfmoon. YPT.

Anna-Maria is a versatile performer who also performs as a puppeteer, dancer and in bilingual British Sign Language productions. With a love of new writing Anna-Maria has worked on a variety of devised, improvised and new writing projects and is one half of sketch and musical comedy act; Strong & Wrong. A keen human rights activist Anna-Maria has worked on pieces that tackle the issues of violence against women, genocide in The Great Lakes Region and most recently with The Brighton Theatre's I Am A Warehouse which looks at the Gaza conflict. Anna-Maria is very excited to have the opportunity to work with Red Ladder on Emma Adams' *Ugly*.

EMMA ADAMS
writer

Emma gained a BA in Drama, Theatre Studies and American Studies at Liverpool Hope in 1991 and an MA in Screenwriting at The Northern Film School in 2003. In the intervening years she worked as a tourist guide, a dinner lady, an orthodontic receptionist and a musician.

Emma is now a writer. She wrote *For Sale*, specifically for the house it was performed in, for The Silver Hammer, and *The Gated Community Radio Hour* for I Love West Leeds Arts Festival, both in 2007. For Red Ladder she wrote *Forgotten Things*, which was shortlisted for the 2009 Meyer-Whitworth Award and acclaimed at the Edinburgh Fringe 2009 receiving 4 and 5 star reviews. She was a Talent at the Berlinale Talent Campus 2008, has written several short films and a feature film *The Big Bad* which is under option to Afan films.

Emma is interested in politics, comics, satire, music, running and dark comedy. She is currently developing a TV series, *Northern Souls*, in collaboration with writer Caroline Mitchell and has just been commissioned by Tada Theatre Company to write a new play *Fareeda The Third* which will première at Edinburgh Festival 2011.

ROD DIXON
Director

Rod grew up in the culturally diverse city of Liverpool. He became Director of Red Ladder Theatre Company in 2006. As Artistic Director of a company with a long and powerful history, Rod is aware of the huge responsibility of the role. Red Ladder has always produced a wide range of work for a wide range of audiences – but always with a core aim of provoking social change. Since the company celebrated its 40th anniversary in 2008 Rod has

pushed hard to make work that is covertly political – and recent collaborations with the anarchist folk band Chumbawamba have helped reposition Red Ladder as a company with a radical ideology. Rod last worked with Emma Adams on the highly successful play 'Forgotten Things' which was nominated for the Meyer Whitworth Award and which received excellent reviews at the Edinburgh Fringe in 2009.

For Rod, the power of Emma's new play Ugly lies in the world which she has created – as feral and cruel as the heath in King Lear but as ridiculous as the worlds in films like Delicatessen or Micmacs by Jean Pierre Jeunet.

PLUM STUPPLE-HARRIS
Assistant Director

Plum has been performing and directing for five years now, most recently he directed a Plymouth based company's adaptation of 'One Flew Over the Cuckoo's Nest' and performed with Frantic Assembly. This is Plum's first production with Red Ladder and he has huge respect for the company's fearless approach to performance. He considers Ugly to be an hilariously gruesome peek into the future of our world. It is not only a warning of things to come but an education on the here and now. Although the piece is grim in places, Plum sees hope in its message.

SARA PERKS
Set & Costume Design

Sara has designed around 90 productions for a variety of venues and genres. She is Associate Artist at the Mercury at Colchester, where she has designed 17 productions, recently and most notably Depot, a multi-discipline site-specific promenade production in a vintage tram station. Current projects are Pinter double bill at Mercury; Hot Stuff and The King and I for Leicester's Curve.

Credits include Spring Storm and Beyond The Horizon (National Theatre; Royal & Derngate);The Wizard Of Oz (Royal & Derngate); Neil LaBute's The Furies/Helter Skelter/Land of the Dead (The Bush and tour); Wedding Day at the Cromagnons (Soho); Treasure Island (Derby Playhouse); The Elixir of Love (Grange Park Opera co-design); Rough For Theatre 1 and 2 (Arts); Return to the Forbidden Planet (national tour); Romeo and Juliet (English Touring Theatre); Singin' in the Rain (Hereford); Dead Funny (Oldham and tour); The Crypt Project, a site-specific piece at St Andrew's, Holborn; and Union Street, Plymouth Theatre Royal's millennium project with a cast of 230. She also designed the original and several subsequent productions of the cult spacerock musical Saucy Jack and the Space Vixens.

Ugly is the second show of Emma Adams' she has designed for Red Ladder, the first being the 'Burtonesque' Forgotten Things. Equally surreal and arguably more disturbing, Ugly on the page conjures post-apocalyptic vistas and cinematic landscapes. In order to condense the scope of the writer's imagination without losing the pervasiveness of her world, it was necessary to design something that had a uniformity and aesthetic cohesion but also allowed infinite flexibility and scope to create different architectural landscapes, with varied dynamics. In short, the screens allows the desperate make'n'mend ethos and desecration to be present, but give the actors and the director the ability to create scenes in rehearsal and 'play', as is conducive to their style of working. Mrs Mason – the eternal optimist -emerges from this world as a future Mother Courage, a bag lady, tinker and survivor extraordinaire – who carries her worldly chattels with her wherever she goes.

And finally….it all had to go into a back of a very, very small van…….

JAYDEV MISTRY
Sound Design

Ugly: is exactly the word that comes to mind when I think of the state of global capitalism and the effect the few who hold true financial power are having on this planet.

Ugly: is the pursuance of wealth without thinking about the consequences.

A total disregard for the suffering of our fellow human beings!

Ugly: is waging war on the poor and the innocent. Did you know that major British banks are investing in companies that build and supply cluster bombs that kill and maim innocent civilians on a regular basis?

Ugly: is the major global corporations not being held accountable!

All companies have a responsibility to respect human rights in their operations!

Ugly: is ignoring the Universal Declaration of Human Rights, Article 1

"All human beings are born free and equal in dignity and rights........."

There are hundreds more definitions I can think of when I think of the word in context to Red Ladder's production of *Ugly*.

Ugly is set in the not too far distant future and tackles many issues that we should all be worried about. Many of the issues raised are already harming the planet and its inhabitants and we should be doing what we can to fight the injustices and environmental catastrophes that are affecting the planet now.

It is too easy for us who live in the west to remain ignorant to plight of the millions who live in abject poverty as a direct result of capitalism.

Jaydev Mistry is a musician, composer and producer whose work has always been informed by the injustices we face locally and globally.

In 2005 he was awarded the Amnesty International Media Award for his work on the BBC radio 4 docu-drama, Bhopal. The radio show highlighted the plight of the people of Bhopal in India, who in 1984, were subjected to the world's worst industrial catastrophe when American corporation Union Carbide's pesticide plant leaked gas and other chemicals into the surrounding areas. Some government agencies estimate that there have been 15000 deaths and people are still suffering from gas related diseases today.

Jaydev was artist in residence at the Contact theatre in Manchester in 2001 where he created an audio and visual installation "Threads" that explored the relationship between Manchester's industrial heritage and the effects of colonialism on India its people and its many varied cultures.

Jaydev has composed music for many theatrical productions for companies such as Peshkar Theatre Company, Pilot Theatre Company, Speakeasy and Community Arts North West. This is Jaydev's 5th production with Red Ladder.

TIM SKELLY
Lighting

In the face of the impending obliteration of life on Earth the role of lighting designer is somewhat questionable. My art uses huge amounts of electrical energy and resources, creating unwanted heat from high wattage filament lamps and bleaching expensive colour media that cannot be re-used.

I'm hoping *Ugly* can buck the trend and be lit almost solely with low voltage rechargable lighting units, LED fittings that combine colour changing control to

avoid the need for the use of additional colour gel, fluorescent tube sources and high pressure sodium and metal halide floodlights.

Tim Skelly is a resident theatre designer and academic at the Workshop Theatre, University of Leeds. He has also worked as an academic at University College Bretton Hall in Wakefield and as a resident practitioner and teacher of lighting design at the Royal Academy of Dramatic Art in London.

As a freelance lighting designer recent professional work includes *NHS* and *Union Street* for Plymouth Theatre Royal; *Wars of the Roses* and *Runaway Diamonds* for West Yorkshire Playhouse; *Doors* and *Forgotten Things* for Red Ladder Theatre Company;

Three Sisters and *Romeo and Juliet* for Colchester Mercury Theatre; *Chiaroscuro,* *Playfall, Plunge, Somewhere Inside* and *High Land* for Scottish Dance Theatre; and technical management and lighting support for *Cattlecall, Picadores,* and *Paseillo* for Phoenix Dance Theatre.

Tim also works as a lighting consultant for *Yorkshire Sculpture Park* and has collaborated with several artists, including lighting designs for Sir Anthony Caro's *The Trojan Wars,* and retrospectives for Philip King and Christo.

In his academic capacity he has won an award from the British Academy Arts and Humanities Research Board to complete a survey of key British Lighting Designers from the late twentieth century.

DIRECTOR'S NOTES

In August 2008 my partner and I went to Kingsnorth in Kent to join the Climate Camp that was set up in protest at the planned new coal powered power station. Climate Camp isn't just a protest by slightly crazy climate activists – the entire set up is a real attempt to experiment with sustainable living using the lowest amount of resources possible with the least impact upon the local ecology. For a week, two thousand people lived together in a non-hierarchical community, making daily decisions using the consensus process. Decisions are reached in a dialogue between equals, who take each other seriously and who recognise each other's equal rights. This kind of mutual respect is the only way forward if we are to keep our world safe and our planet alive.

Unfortunately, this wonderful experiment in communal living on the land was disrupted by 1400 police officers, brought in to prevent the direct action – we had stated that our aim was to shut the power station down. In this business-driven society such a threat to property is deemed an act of terrorism – and thus our camp was surrounded by riot police who raided us at 4am with dogs and threatened to baton charge us. They were dressed in armour like medieval foot soldiers …we were clad in flip-flops and shorts.

The policing at Kingsnorth has since been acknowledged as 'over-kill' and Kent police have officially apologised (on behalf of the Met Police Sergeant who whacked me with his shield I presume). However, there is no doubt that what we experienced that week was the full force of the State thrown into a panic. The powers that be *know* that oil is reaching peak production, they *know* that the levels of carbon we are pumping into the atmosphere are suicidal for the planet and therefore the human race… but they just cannot face up to the massive changes that are needed – the State is in a state of fear. The Climate Activist Movement is leading the way – but like all radical movements throughout history, their ideas are suppressed and ridiculed.

'Ugly' is a glimpse of the world that we seem to be heading towards. Typically, Emma Adams has written a play that ingeniously counterbalances the horrors of a possible future with surreal and satirical comedy. We want audiences to be shocked and yet amused by the play – but like all Emma's work we want the play to be a catalyst for deep and useful debate.

WRITER'S NOTES

I met Rod Dixon, Red Ladder's Artistic Director, in 2006. I had written to him about an idea for a play and two days after posting this I got a phone call from him. He was talking talking talking, excitable and bouncing from one topic to the next. "Yeah! Yeah! Cool! Come to the office," he said. So I did, and we talked for hours about everything: politics, life, the works… He never asked to read a completed script, and simply on the strength of a treatment, 3 sample scenes and on that conversation he commissioned Forgotten Things. That's how Rod works. He gets a feeling in his gut and he goes with it. But now that I know him, I've also learnt that beneath the spontaneous energy there is a nuanced method. His belief in the means, not just the ends of the work he does, is an inspiration. The upshot is he puts his money where his mouth is and is an incredibly generous collaborator. But that doesn't mean he doesn't know what he's looking for. When he commissioned me to write Ugly, his only stipulation was that I should write the play I believed in. I came back to him with a treatment and he sent me away, insisting that I start again from scratch. I didn't really understand. I felt the treatment was good. He said, "No, you can do better!" I'm not going to lie: that moment was incredibly tough, but creatively it was probably one of the most important conversations I've ever had. It's a privilege but also a high bar to work with someone like Rod. He throws himself out of windows trusting that he will learn how to fly on the way down. Which is all well and good, only that day I realised that to work with him you have to take the leap and do the same thing. I'm indebted to his unfailing support and belief in me.

UGLY

Emma Adams

UGLY

OBERON BOOKS
LONDON

First published in 2010 by Oberon Books Ltd
521 Caledonian Road, London N7 9RH
Tel: 020 7607 3637 / Fax: 020 7607 3629
e-mail: info@oberonbooks.com
www.oberonbooks.com

A catalogue record for this book is available from the British
Library.

ISBN: 978-1-84943-021-0

Cover design by madebyanalogue

Printed in Great Britain by CPI Antony Rowe, Chippenham.

Characters

THE BORDER GUARD
a very young man.

WOODY
20, a female army officer.

BEN
20, a gifted student.

MRS MASON
55, a disgraced home economics teacher.

MERT
19, an illegal immigrant from Africa.

Plus: Guards, 3 different Women, The Landlord, Voices, Official Voice and Calm Voice - played / voiced by members of the cast.

Ugly was first performed at The Carriageworks, Leeds on 27th September 2010.

Cast

THE BORDER GUARD, Calum Clark

WOODY, Rebecca Rogers

BEN, Pete Hinton

MRS MASON, Jo Mousley

MERT, Anna-Maria Nabirye

Creative Team

Writer, Emma Adams

Director, Rod Dixon

Assistant Director, Plum Stupple-Harris

Set & Costume Design, Sara Perks

Sound Design, Jaydev Mistry

Lighting Design, Tim Skelly

Stage Management, Calum Clark

Assistant Technician, Jason Barker

Set Builders, Q Division

SCENE 1 - BORDER CONTROL - NIGHT

DARKNESS.

DISTANT BUT SURROUNDING SOUNDS of high wind, sporadic gunfire, voices and multiple wind-up mechanisms / clockwork cogs unwinding...

Out of this soundscape THE DISTINCT SOUND OF FOOTSTEPS GETTING NEARER...

And now, the BLURRED SOUND OF VOICES SHARPEN into a distinct, caught conversation...

VOICE: *(Off.)* Neither you nor your tag is in order! You are not proper. Kneel.

WOMAN: *(Off.)* Wait.

VOICE: *(Off.)* Guard slate that she is NonSpec.

WOMAN: *(Off.)* Take a card. Any card.

GUARD: *(Off.)* Slated.

WOMAN: *(Off.)* Please, just pick a card.

VOICE: *(Off.)* You, new boy!... Yes you!

The SOUND of footsteps stops.

WOMAN: *(Off.)* But everyone needs magic.

VOICE: *(Off.)* Watch and learn.

The BLISTERING SOUND of a single gunshot...

And now the SOUND of the footsteps RUNNING, pounding nearer and nearer... The SOUND of a door opening... Footsteps enter the space...

The SOUND of a WIND-UP TORCH being wound...

Which then suddenly lights the space...

The torch is held by THE BORDER GUARD (very young, thin, spattered with blood). His uniform is neat but patched. He is retching but trying not to throw up...

There is a desk. It straddles a chalk line.

On one side of the line a sign reads 'Special'.

On the other side another reads 'NonSpec'.

He sits behind the desk facing the NonSpec sign.

He places his torch down then tidies the already neat desk, rearranging a water filter jug, a glass, roof slates, pebbles, a football rattle and a wind-up alarm clock.

THE BORDER GUARD manages to stop retching... He pours half a cup of water. He checks the alarm clock and a slate... Now he grabs the glass and slugs it down...

He makes a tick on another slate. He looks at his empty glass... And then quite suddenly, he starts to cry...

The ALARM CLOCK on the desk goes off.

THE BORDER GUARD panics, wipes his eyes and nose, licking the moisture and blood from his fingers, quickly, expertly. He doesn't waste a drop. Now he is ready...

THE BORDER GUARD: Alright. COME.

WOODY (female, 20, sunburnt) in desert army fatigues and BEN (20, thin) wearing a miniature mortarboard, university scarf, shorts & flipflops, emerge from the Special entrance, behind THE BORDER GUARD.

THE BORDER GUARD, unaware of this, looks up annoyed.

BEN is anxious, nervous. WOODY just grins...

THE BORDER GUARD: Come! Don't tardy! Tags! There's no time to waste.

WOODY: There must be no waste at all!

THE BORDER GUARD jumps out of his skin.

WOODY: Preparation is everything.

BEN: But even so, we didn't mean to frighten you, we…

THE BORDER GUARD takes his chair round the table then sits facing BEN and WOODY.

THE BORDER GUARD: I was not frightened… Just. Tags. Come… Come!

WOODY points to a stripe on her uniform.

THE BORDER GUARD: Oh… Excuse me Ma'am. I didn't see

WOODY glares at THE BORDER GUARD.

BEN: Should we just give him the tags? Woody?

THE BORDER GUARD: Yes… Tags please Ma'am… Tags… Now please.

WOODY: 'Now' is it!?

THE BORDER GUARD grabs a slate and pebble.

THE BORDER GUARD: I must warn you that I am now officially documenting. You must show your tags.

BEN: Everyone?

WOODY grabs a slate and a pebble too.

WOODY: Fine!

BEN: Let's start again. Soldier, this is Officer Woodward and

WOODY: I'm documenting you documenting me… Failing to salute an officer, signs of illegal moisture, acting dumb as shit! Conclusion: Potential NonSpec! Recommendation?

THE BORDER GUARD leaps up pointing a pistol at Woody.

THE BORDER GUARD: You violate the special list and my place on it. Do you denounce me?

WOODY grins then pulls out her pistol and points it at THE BORDER GUARD, who instantly points his at BEN, who instantly puts his hands up...

THE BORDER GUARD: Ma'am, any guard or soldier who may be deemed special, half special, super special or almost special, may bear arms to defend against false denouncing. Do you insult me?

BEN: We all just need to calm down. All of us...

WOODY: Well you look NonSpec to me.

BEN: Woody!

WOODY: Pull the trigger! Go on! Do it!

THE BORDER GUARD snaps, swings the pistol round, points it at WOODY and pulls the trigger.... It simply clicks.

WOODY starts to giggle. She rips the pistol from THE BORDER GUARD and clicks the safety catch off... But then immediately hands the pistol back.

BEN: What the fuck are you doing?

WOODY: Your safety needs to be off, numb nuts!

THE BORDER GUARD looks at his weapon then slowly points it back at WOODY and BEN.

THE BORDER GUARD: Thank you Ma'am... You're under arrest.

BEN: Why would you give him the gun back?

WOODY: It's a pistol. And I'm not under arrest... Ben, show him.

BEN: No!

THE BORDER GUARD: Show me what?

BEN: It isn't a toy.

THE BORDER GUARD swings his pistol back at BEN.

THE BORDER GUARD: Show me! Now!

BEN takes a car wing mirror from his pocket, then turns it towards THE BORDER GUARD.

THE BORDER GUARD still pointing his pistol immediately looks away.

THE BORDER GUARD: But I didn't realise you were an Extra Super Special sir!

BEN: I don't always wear my big hat and coat... Look, please just put the gun, pistol, down.

THE BORDER GUARD puts down his pistol.

WOODY pushes BEN away and smiles at THE BORDER GUARD, suddenly friendly...

WOODY: It's alright. We were just fucking with you... Have you been crying?

THE BORDER GUARD: I don't cry. It is not permitted...

WOODY: Soldier! We put our life on the line everyday to protect the future of Specialness because we believe in Ben and his kind. They hold the key to a beautiful future. And we'll get there, if we can hang on... And we can can't we? We can hang on?

THE BORDER GUARD: I try.

WOODY: Good man!

THE BORDER GUARD and WOODY salute each other.

THE BORDER GUARD: I would love to hear him talk. Do you think he might Ma'am?

WOODY: Extra Super Special Ben? Would you? For us?

BEN reluctantly peers into his wing mirror.

BEN: I look and I see my own perfection... In seeing it I see what you see and so it becomes yours even though of

25

course it is mine... Those who are perfect may seize the day. In seizing the day we make it better. In a better day we reach my potential. My potential is beyond the weakness of hopeless thoughts. Truly, life has never been better.

THE BORDER GUARD: Whoosh. He's good... I mean properly Special.

WOODY: I know. He's proper!

THE BORDER GUARD: No! I mean I feel better just looking at him! Having him in the room with us.

BEN: Thank you Soldier, but now, could we finish the slate work?

THE BORDER GUARD: Of course! I will accelerate. Names please?

WOODY: Officer Woodward, Amy, 8th Eurozone Company, Search and Dispatch.

THE BORDER GUARD: The 8th! Really?

WOODY: Really!

BEN: Alternatively, we could all just chat the night away?

WOODY: And I'm always looking for men who want to transfer.

Exasperated, BEN grabs a slate and starts chalking.

BEN: Luxton, Ben, Extra Super Special. BA in Myself, I and Double Narcissistics. Present research: The applied and many meanings of me.

BEN slaps the slate down.

THE BORDER GUARD: So, I suppose you two are on an extra special 'secret' mission then?

WOODY winks at THE BORDER GUARD.

THE BORDER GUARD: I knew it! I better put it down as a holiday. Don't want to blow your cover Ma'am.

THE BORDER GUARD scribbles on his slate.

BEN: So we can go now?

THE BORDER GUARD: Yes! Well. Almost... Because... I still do need to see your

BEN: Of course. Yes. Of course. The Tags. Woody? The Tags.

BEN holds his mirror up and stares into it, nervous while WOODY produces two brass tags each on the end of a tattered blue ribbon.

THE BORDER GUARD takes the tags...Then stops.

THE BORDER GUARD: But Ma'am! These don't seem...

WOODY: They are proper.

THE BORDER GUARD starts to swing and weigh the tags... And then suddenly he bites them.

THE BORDER GUARD: They look proper but no, I don't think they are!

BEN: Is there some mistake? Is he saying we are not permitted?

WOODY: They're perfect. They're proper. They are very proper tags.

THE BORDER GUARD: I think... I'm sorry... I think I may have to rattle for my supervisor.

BEN: Do you really need to do that?

WOODY: You know, he may need to. He may. It's a tough call.

THE BORDER GUARD looks at WOODY then licks the tags.

WOODY: They are proper tags. But rattle for your supervisor.

BEN: Or don't. Why would we have anything but proper tags?

WOODY: Ben, let me talk with our special friend.

BEN: Only, I think perhaps I should do the talking? Since we arrived you do seem to have been confusing things. A little. Maybe I could use my extra special skills to help things along?

WOODY: But you don't understand Army ways! If this special soldier fears that our tags may be NonSpec in any way then he must rattle for his supervisor. It's what I would do.

THE BORDER GUARD: You would?

WOODY: To say to your supervisor, 'I'm sorry to interrupt your permitted yank time, only I am new and confused.' That takes courage! If he's wrong, who knows what could happen?

THE BORDER GUARD: It's really his permitted night for yanking?

WOODY: It could be. He may be yanking as we speak.

THE BORDER GUARD: I had not thought.

WOODY: And why would you? That is not your job.

THE BORDER GUARD: But I must be certain. Otherwise it could be time wasting.

BEN: Stop it, both of you... There is no time left to waste!

WOODY: He's got a point. He's always fucking right. But then he is an Extra Super Special.

Silence

THE BORDER GUARD: I was mistaken. I beg your pardon. I see now. The tags are proper.

BEN: Great! OK! That is great news... Let's go. Let's just

WOODY: You're sure? I don't want anything to do with them if they are strange.

THE BORDER GUARD: They are not strange. They are proper. I'm certain.

WOODY unzips a pocket and hands him a health chew.

WOODY: You'd fit in my Company soldier. If you want a new life in Malta, slate me.

THE BORDER GUARD: Yes Ma'am!

WOODY grins as she and BEN pull tags over their heads.

THE BORDER GUARD salutes as WOODY and BEN...

SCENE 2 - NO MAN'S LAND - NIGHT

... are suddenly running. WOODY agile. BEN skittish... The SOUND of high wind and clockwork, as scene 1 morphs into scene 2, revealing broken junk and a massive fence.

CALM VOICE: *(Warped Recorded)* Welcome to No Man's Land, a necessary place which protects the Special way of life. You will shortly encounter some tests. The strong and Special have nothing to fear.

BEN: Woody?!

CALM VOICE: *(Warped Recorded)* If you can reach the gate and hand in your tag this means you are Special. Well done. Feel free to enjoy your stay but remember, your tags give access to the Non Spec zone only until the other side of tomorrow.

WOODY: The other side of tomorrow!

CALM VOICE: *(Warped Recorded)* If you violate your commitments or over stay, your Special status can not be guaranteed.

WOODY: A holiday!

CALM VOICE: *(Warped Recorded)* NonSpecs are not Special and have no right of return.

A sudden explosion throws BEN one way and WOODY the other...

DARKNESS...

Search lights swoop light across the space,

WOODY, appears half in shadow, crouching, scanning...

WOODY: Ben! You ok? You ok? Ben!

The search light swoops. WOODY rolls into shadow and disappears, just as BEN comes crawling into half view.

BEN gets up. There is a sudden SOUND of Gun Fire. BEN immediately throws himself back on the ground.

BEN: Stop shooting at me!

WOODY: *(Off.)* Ben! Quiet! I'm coming!

BEN: Woody where are you?

WOODY, reappears dodging the sweeping light.

WOODY: Quiet!

WOODY suddenly leaps on BEN, puts a hand over his mouth and they lie there for a moment, still.

WOODY's grip turns to an intense hug and she kisses BEN on the top of his head.

BEN twists round and stares at her.

WOODY winks, as if nothing has just happened...

BEN: You said the tests would be a formality!

WOODY: Hear the clockwork?

BEN: My hearing is exceptional.

WOODY: It's slowing down. We sit tight until they have to rewind it...

BEN: This isn't what I was expecting.

WOODY: Just stop whining! It's called having a smirk!

WOODY suddenly leaps up flicking the V's...

WOODY: Oy! 7th! A message from the 8th! You missed! Yeah! You're a bunch of queertarded HalfSpec wetfuck spaztards and you will never touch me! Got that?

The SOUND of a HUGE burst of gun fire. WOODY leaps back to lie by BEN, hyper with adrenalin.

WOODY: Did you see me? Did you see that?! Come on!

BEN: Amy I saw. Yes... I saw.. But... Because, since you got back? You've been... You've been unusually lively Amy and

WOODY: I told you, no one calls me Amy anymore.

BEN: Fuck off! Do you know how close that Border Guard was to rattling for his supervisor?

WOODY: But he didn't.

BEN: No thanks to you. You said the fake tags would look proper.

WOODY: I didn't expect him to bite them.

BEN: This is so fucked... We need a plan.

WOODY: We're not Ghetto jumping to do thinking.

BEN: Clearly. But if we just did a little bit of it, we might live long enough to actually arrive.

Silence

WOODY: You used to be fun, before you got that fucking mirror.

BEN: Its a responsibility. You wouldn't understand.

WOODY: I understand! Everyone in the 8th needs the Ghetto when they come off tour. Blast Forget. Whoosh! Smirk! Forget forget forget... I am fucking special! I deserve it.

BEN: It's not easy being an Extra Super Special. I need some smirks too.

The SOUND of the clockwork slowing down...the sweeping search beams begin to stutter and fade.

WOODY: Yeah? We'll see! You ready?!

WOODY produces some wire cutters.

BEN: We have tags! The instructions clearly stated reach the gate and present your tags.

WOODY: Gates are for NonSpecs. In the 8th we cut our way in.

BEN: What?

WOODY: So, when I say Run...

BEN: No.

The SOUND of clockwork stutters to stop... The Search Lights begin to fade... WOODY grins at BEN...

BEN: Amy?.. Woody!

And then the search lights snap to DARKNESS

WOODY: *(Unseen in darkness.)* Run!

SCENE 3 - NONSPEC GHETTO - NIGHT

DARKNESS

The SOUND of HIGH WINDS. The SOUND not far off of a group starting to fight, screaming, crying...

SHOUTING WOMAN: *(Off.)* Baby Chops. Succulent crackling. Yours for fresh piss.

And now The NonSpec Zone is revealed. It's a place of mind boggling squalor. Broken buildings, tents, dirt, noise, but bright and gaudy too...

CALM VOICE: *(Warped Recorded)* NonSpecs! Die and claim posthumous Special status. Limited offer, conditions apply.

SHOUTING MAN: *(Off.)* Boy, 10, never fucked. Be the first. Five energy chews and a cup of water.

WOODY and BEN fall out of a gaudily lit doorway. They are high, smashed and grinning.

WOODY: This is. God it's like heaven. We can be anything, have anyone we want!

A WOMAN in rags runs towards them.

WOMAN: Specials in the Ghetto!? You want it, ask. I'm your girl, OK?

WOODY: Dog.

The WOMAN takes out two syringes full of green liquid.

WOMAN: I got Green Forget. The best Forget going. I promise you want this.

BEN: We had Blue already and it is very, very excellent, let me tell you.

WOMAN: This shits on your regular Blue!

BEN: Really?

WOODY: He doesn't want to fuck a dog like you!

BEN: Shh Woods shh

WOMAN: Makes you 100% fucking machine.

BEN: And you can do what you want?

WOMAN: When you want. No tardy.

WOODY: But Blue does that.

WOMAN: Green's better, better, better. Ok?

BEN: And after? After? We still forget?

WOMAN: Everything. Just like normal. Just like Blue. But better. You're Special. You deserve Green. Try Green.

WOODY snatches at the syringes but the WOMAN is fast.

WOMAN: Ten health chews.

WOODY: Two!

WOMAN: One water, seven chews

WOODY: No water, four chews!

The WOMAN hands WOODY the syringes. WOODY throws four energy chews to her. She turns and runs.

WOODY: This place is everything the guys couldn't remember about it. How many fucks we done?

BEN: You fucked three boys and I've done four. Four girls.

WOODY: I did coming and everything!

BEN: Yeah. Yeah. It was great.

WOODY: My boys were good, skinny but good. Nothing to stop us here... Your girls? Were they good? You get good ones?

BEN: Yeah...

WOODY: Yeah? How yeah?

BEN: They were just great OK?

WOODY: You forgetting too soon? Can't forget yet. Not yet. Other side of tomorrow, not yet!

BEN: It's OK. Top up. Lets just top up.

WOODY: Top up!

WOODY shoots her pistol into the air and hollers.

WOODY: Want a go? Come on. Have a go. Have a go. Have it.

BEN takes the pistol and whoops as he fires it into the air.

WOODY: We're having a smirk Ben. Are you having a smirk?

BEN: I'm smirked off my head!

WOODY: Us together again!

WOODY holds up the two syringes filled with green liquid.

BEN: Smirking!

WOODY: Because I'd die for you.

BEN: Cos I'm Special Extra Super Special baby!

WOODY: I would! Listen! I would. I'd die for you. You. Everything for you.

WOODY suddenly kisses BEN. For real, but BEN pulls away.

BEN: Amy?

WOODY's stung... But then, just as suddenly, grins like nothing happened.

WOODY: Ready for Green Forget?

BEN: Amy!

WOODY: What? You ready Ben?.. Come on! You Special enough?

BEN: Yeah.. Ok. Ready... Special Special Special 100 percent fucking machine. That's me.

WOODY offers a syringe. BEN moves to take it but WOODY, teasing, snatches it away and runs off.

WOODY: Special. Always. We're proper, you and me.

SCENE 4 - GHETTO ALLEY - NIGHT

*WOODY and BEN run, whooping, as SOUNDS of mayhem die down...
finally they find themselves in a dark alley.*

WOODY: Together!

WOODY and BEN snort the Green and hit instant Euphoria!

WOODY: Whoosh. On top, I'm on top. Nothing! No tardy.
No problems. Accelerate

BEN: Only me. Only me.

WOODY: And the wind sounds different.

BEN: I've got a hard on you wouldn't believe!

WOODY: Like chimes not screaming. Not crying. Like
singing.

BEN: And my mouth isn't dry! Woody! I'm not thirsty.

WOODY: A holiday!

Both friends grin at each other.

BEN: Only... Woody... My legs are...

Suddenly, BEN, still grinning, slumps down...

BEN: My legs! I can't make them.

WOODY: Yeah? Don't worry. Fine all fine. Accelerator!

WOODY suddenly slumps down too...

WOODY: Still brilliant. Just no legs now!

BEN and WOODY lie there together and start to laugh.

BEN: Fucking. My... my legs! I can't move them. Spreading
up.

WOODY: Feels so good!

*BEN and WOODY laugh harder and harder but then BEN suddenly
stops, starts to panic, WOODY doesn't notice...*

BEN: Amy! Shit...

WOODY stops laughing, tries to reach out to BEN but she can't use her arms anymore.

BEN: What's happening? What?!

WOODY: I don't. I don't know.

BEN: Arms now! Are we dying?

Silence

BEN: I can't move...

WOODY: Wanted to go fighting.

Silence

WOODY: Are you dead?

BEN: I'm thinking.

WOODY: Only you could be doing that now.

BEN: We're dying. This is it.

Silence

WOODY: Doesn't hurt though, that's good.

BEN: Good?

Silence

WOODY: Don't be dried off with me.

BEN: I'm not! It's the situation.

WOODY: I know what you sound like.

BEN: Woody! I'm not... I'm scared OK.

WOODY: Extra Super specials don't get scared.

Silence

BEN: But what if I'm not?

WOODY: Not what?

BEN: Not Special.

WOODY: No.

BEN: Woody?

WOODY: Not permitted.

BEN: I need to talk.

WOODY: You're special. I'm special. Nothing will ever change that. Not getting dead. Nothing.

BEN: I haven't seen anything special in the mirror for months. Just copy what the other students say. I'm glad I'm dying. Uni would have found out and I'd have ended up here.

WOODY: You are here.

BEN: But we're on holiday. I mean. I think I'm NonSpec. I'm scared I am and

WOODY: You're the best person I've ever met. I joined the army to protect you.

BEN: No you didn't! You joined because you wanted to use vehicles.

WOODY: And to drive vehicles too. And smell Petrol. And see last bird. Last bird. Wings.

BEN: Gone now. Better off without it clogging up the sky.

Silence

WOODY: See you make things better. Extra Super Special... Love you Ben... All the things... things... that I... things make sense when I think of you.

BEN: I love you too.

WOODY: Not like I love you... Love love... In a proper way... It's alright I know you don't love me like that.

BEN: What do you mean? Like that. I do girls.

WOODY: But you never wanted to do me did you?

BEN: I do girls. I do...Gir-Gir-Girls... Wood-Dy! Mmmy

WOODY: Just not me... Doesn't matter. Clever, beautiful boy.

BEN: Wood-Dy? Mmmmmy-Jaw!

WOODY: Spesh-Aaaaaal.

BEN and WOODY stare at each other, eyes darting, unable to move or speak. They start to make guttural screams... And then stop and just lie still, eyes darting, darting...

SCENE 5 - GHETTO ALLEY - NIGHT

MRS MASON appears from the shadows: 55, stick thin, in a filthy patched frock, pinny and mismatched heels. Made up but dirty, her hair is tied with a girlish ribbon. She carries a rolling pin and a broken basket.

MRS MASON: Darlings, I just couldn't help overhearing...
About your gloomy prognosis? Bad luck. Only I wonder?
Once you're gone. Your things?.. Might they need a new
home?

MRS MASON waits for a reply but, unable to move, all WOODY and BEN can do is make agitated guttural sounds.

Finally MRS MASON clocks the dropped syringes, picks them up and sniffs at them.

MRS MASON: Why the Resistance feel they must keep slipping
FuckU to all the tourists I shall never know! Can they think
of nothing but the revolution? The amount of my parties
they've come to and ruined... And I so love a soiree! No
one talks a lemon drizzle like I do!.. A lot of memories...
Tim loved cake... But shh shh shh! We mustn't talk of silly
sad things.

Mrs Mason turns to go then stops.

MRS MASON: Only, I do hope this little mix up won't stop you holidaying in the NonSpec zone again? If you survive? I hope you do! Fingers and toes crossed! Alright? Ciao darlings.

MRS MASON darts into the shadows and is gone.

Left alone, WOODY and BEN's guttural terror returns and builds until, suddenly MRS MASON appears again.

MRS MASON: Shh! We don't want to start smelling of fear do we? That will never do!

MRS MASON turns to leave again but now WOODY and BEN's guttural screams grow even more insistent.

MRS MASON: Well I suppose... But I mustn't stay long. The rent must be paid. Goodness yes. The rent... It must be paid today. The rain is coming...But there again...

MRS MASON props WOODY and BEN up to a slumped sit.

MRS MASON: We ought to make the best of every situation that we find ourselves in, oughtn't we?

MRS MASON squeezes in between WOODY and BEN.

MRS MASON: And I do love a chance to meet new young people... I have a Son. About your age... Marvelous Tim... Moving up in Landfill...Very busy of course...Darling? If you survive, you will let your Mother know won't you? You boys can be so forgetful.

MRS MASON prods BEN... he just grunts... so then she grabs his head and nods it in agreement...

MRS MASON: Good boy. I like you. Familiar... Reminds me of a time... class baking... A perfect lovely afternoon. I said tish and tosh to Algebra and we all cheered. We worked out how many eggs it would take to bake a cake for the whole school instead! Weren't eggs wonderful!

MRS MASON suddenly leaps at the shadows with her rolling pin, causing BEN and WOODY to slop prone again.

MRS MASON: Get away there! Rat Children! Little snouts, sniffing you out...

MRS MASON scans the shadows until she's certain they've gone.

MRS MASON: They'll run squealing to the Resistance. A perfect pickle.. Think Lydia!.. Home? Home!.. No... But. Well now! Yes!.. Goodness though... It will have to look real.

MRS MASON lifts WOODY's head and looks into her eyes.

MRS MASON: So familiar... Darlings, the Resistance use certain techniques. Trademarks... So we will fool them! But you must be brave. Just lie back and think of beautiful things! Alright?

MRS MASON suddenly starts to violently attack WOODY... Stamping her with her heels, ripping her clothes...

Now she produces a huge kitchen knife...

MRS MASON: Deep breath now dear.

MRS MASON rips WOODY's boots off and slits her feet open. Blood pours as WOODY screeches guttural agony.

MRS MASON: Shh!

MRS MASON smears the blood all over WOODY. Then turns to whimpering BEN and starts slashing his clothes...

MRS MASON: I told you! It won't work if it doesn't look real. Be a brave boy.

Now MRS MASON lunges her knife into his arm, positions him so it looks like a stab to the heart, then smears him in blood too. All the while BEN screaming guttural yelps...

At last MRS MASON steps back to survey her handiwork.

MRS MASON: Children! Shh now! Because, do you know? From a distance it's perfection! Utterly convincing. Just like the plays we put on in drama club.... Wonderful times.

The SOUND of distant thunder.

MRS MASON starts to hurry, ripping all their belongings, including their tags, health chews and WOODY's pistol.

MRS MASON: The rest is down to you! Blend in! No noise!.. Find me in the bohemian quarter. Alright? Everyone knows me. Just ask for Mrs Mason.

MRS MASON is tottering off when she registers WOODY's Army dog tags... She reads them... Then stops dead...

MRS MASON: Oh my good lord! I knew I knew you! Tim's best friends, come to visit!

The SOUND of distant thunder a little nearer.

MRS MASON: But Amy and Benjamin, why arrive with the rain? Of all the days to come!

Another CRACK OF THUNDER, nearer still...

MRS MASON: But never mind, it's fine! We shall just make a wonderful change of plan! Come along!

SCENE 6 - MRS MASON'S BASEMENT - NIGHT

MRS MASON struggles to drag WOODY and BEN. As she goes the SOUND of the Ghetto fades and the scene morphs into MRS MASON's basement: A manic hotch potch of brothel, kitchen, library and charity shop...

Treasures include an exercise bike, an old Kenwood mixer, a kettle, fairy lights that illuminate the room, a book shelf covered in hundreds of ancient 'Good Housekeeping' magazines, hair ribbons, pinnies, whisks, feather boas, a sack of sawdust and an old fashioned record player... Above is a skylight. In one corner there's a doorway, in the other there's a ripped silk curtain...

MRS MASON collapses on top of WOODY and BEN.

MRS MASON: Welcome to Chez Mason!

The fairy lights begin to flicker and fade.

MRS MASON: Only, would you excuse me for just one moment?

MRS MASON pedals the exercise bike. The fairy lights flare up... And now the record player slurs a warped copy of 'Un Homme Et Une Femme' by Paul Mauriat

MRS MASON: What a wonderful time we are going to have... But where are my manners? Who would like some tea?.. Real water and sawdust tea! What a treat!

MRS MASON spoons sawdust into her teapot then pours a chunk of WOODY's water into her kettle and clicks it on.

Instant darkness as the lights and record player fail...

MRS MASON stumbles back to the exercise bike and pedals hard. Slowly the lights, music and kettle come back on.

MRS MASON: I need a new vehicle battery. Tim used to dig them from the tip... But it's difficult for him to visit here... I have written to the Minister for Mistakes but he's a very ignorant man! Still, we are not downhearted! The cake may rise slowly, but the time for icing will come!

The kettle boils. MRS MASON pours water into the teapot.

MRS MASON: Not that I talk about icing for revolutionary purposes you understand?

MRS MASON presents tea to WOODY and BEN who just lie limp.

MRS MASON: Despite what that lying b.i.t.c.h. of a teaching assistant said she overheard, I have completely accepted sawdust tea just like every other Special.

MRS MASON takes a very purposeful sip of her tea...

MRS MASON: See?.. Though, I do enjoy a memory... Not with insurgent intent! Never for that! Just. Memories.. Lovely... Mr Ackroyd's pie shop! Timmy and home...

MRS MASON takes WOODY and BEN's tags from her basket, puts them on and is transported....

MRS MASON: To go home!.. To be Special again!

But then the lovely memory is gone.

MRS MASON: You haven't even touched your tea! Why ever not?..

MRS MASON prods at BEN and WOODY who are still only able to move their eyes. So she drinks their tea for them.

MRS MASON: This batch of FuckU does seem strong! Why the Resistance must call it that I don't know. There is no circumstance that can not be improved with delicacy and imagination! So don't worry! Even if you're crippled for life, I will never even think of eating you.

BEN and WOODY start to scream now, until, finally...

BEN: Mmmmm

MRS MASON: Oh but he's coming back to us!

BEN: Mmmmm

MRS MASON: Try and enunciate, I can't understand a word!

BEN: Mmmmmy arm.

MRS MASON: Yes! Arm! Yes!?

BEN: Ge-Get. Knife. Out...

MRS MASON: Benjamin! That was almost a whole sentence!

WOODY: Dddd-Don-Don-Don

MRS MASON: Amy too! Oh Whoosh! Isn't that what you young ones say now?

BEN: Knife. Accelerate!

MRS MASON: Come on Amy. Are you going to let a boy beat you?

WOODY: Ddddon't. Don't tardy with Non Spec Scum... Enemy.

MRS MASON: Enemy?

BEN: It hurts Woody.

MRS MASON: Could the woman who introduced you to Swiss Cheese Fondue be the enemy?

WOODY: No! No Fondue. Not permitted to talk of Fondue. You know this.

There is a sudden MASSIVE CRACK OF THUNDER... Immediately followed by THE SOUND of heavy rain...

MRS MASON: Amy of course, you are quite right! Fondues are rightly in the past... Only darlings listen, because

BEN: Please! Accelerate.

MRS MASON: Mrs M got carried away with her guests and forgot about the rain clouds looming.

WOODY: Scum. Not to be trusted.

The SOUND of rain pouring gets louder and heavier.

MRS MASON: Dear hearts! I must have your attention.

BEN: Get it out!

WOODY: Everyone trusted you. But you spread lies!

MRS MASON: No Amy dear I did not! I simply noticed that the sawdust was sawdust and not 'excellent flour and tea substitute'.

WOODY: It is excellent. We have no need for flour or tea any more.

The SOUND of rain thunders...and now beneath this, the SOUND of people screaming begins to grow.

MRS MASON claps her hands for silence.

MRS MASON: Children! Circle time though wonderful, really now must end, because when the death-rain falls, my landlord comes to collect his rent. It's a little tradition we have...

BEN: Please, please get it out!

MRS MASON: I am a favorite of his you see and so I get to live up the hill. Which means we are very lucky... Though of course sometimes I do wish we were further up still...

MRS MASON takes armbands from her basket and pops one each onto WOODY and BEN's still limp arms.

MRS MASON: But we must be thankful for what we have! Yes we must... Only dear hearts here lies my tiny bijou problem...

BEN: The Knife. The Knife. The Knife. The Knife.

MRS MASON: My landlord is high in the Resistance and

WOODY: You've betrayed us... How do you live with yourself? How do you live?

MRS MASON: What an interesting question! Well memories help... And I've found having a very tight front zar-zar to be quite an unexpected advantage... But we must stop chattering and

The SOUND of desperate knocking and shouting.

MRS MASON: He's here. I will try and keep him from finding you. But you must be quiet.

SOUNDS of banging and the raging waters getting louder.

MRS MASON: I'm sure I can trust you. But just to be sure. You understand darlings?

MRS MASON takes feather boas and stuffs them in WOODY and BEN's mouths, then binds their limbs.

WOODY: No! No! Get off. Don't

BEN: Please don't hurt us again.

More SOUNDS of BANGING

MRS MASON: We'll laugh about this later... Only just in case, I'll say my good-byes. Love you so much. So wonderful to have seen you again.

LOUDER SOUNDS of Banging, Shouting and Screaming.

MRS MASON: Just coming my darling. Hang on to the rope big strong boy... Ever so quiet now. Ever so... Don't let the death water take my Daddy from me! I'm coming as fast as I can!

LANDLORD: *(Off.)* Let me in! The shit is coming..

MRS MASON: Daddy wouldn't want to see Mummy unless she's looking her best would he?

MRS MASON runs through the silk covered doorway.

The SOUND of a door being unbolted.

MRS MASON: *(Off.)* Daddy's safe from the death rain now.

LANDLORD: *(Off.)* When it rains you unbolt the door! Useless bitch. Or do you want me to drown?

The SOUND of a HARD SLAP.

MRS MASON: *(Off.)* Daddy! You know I live for rent days.

LANDLORD: *(Off.)* You used to... Get off me... Take me through.

MRS MASON: *(Off.)* Let me prove it. Right here. Daddy... Darling?.. Shall we remember sticky toffee pudding?.. No?.. Lemon drizzle?.. You know how that drives you wild.

LANDLORD: *(Off.)* I want Big Mac.

MRS MASON: *(Off.)* We can do better than that can't we?

LANDLORD: *(Off.)* I said I want fucking Big Mac! Make me remember.

MRS MASON: *(Off.)* Let me remember pea and prawn risotto. I can make you come darling.

The SUDDEN SOUND of a punch connecting.

LANDLORD: *(Off.)* I want it my way. I deserve it. I want to remember cheese and gherkins. Tell me about the fucking gherkins...

The SOUND of the desperate beating intensifies. MRS MASON cries out over and over.

MRS MASON: *(Off.)* Please Daddy. Please don't. I never ate it. I don't know. Please.

LANDLORD: *(Off.)* Useless, fucking bitch. Shut up then. Just shut up. Just shut up. Shut up.

BEN and WOODY lie, choked and bound in feathers, forced to listen to the SOUND of the rain and the people drowning outside while the Landlord beats MRS MASON.

BEN begins to cry. WOODY, eyes wide, listens impassive...

And then MRS MASON stops making any sound... The beating stops, then the fairy lights begin to flicker...Until finally the room falls into a dark, terrible silence.

SCENE 7 - MRS MASON'S BASEMENT - DAWN INTO MORNING

Dawn light filters down from the skylight above...

WOODY still, lies eyes wide. BEN wakens, knife still stuck in his arm. They find they can move again and begin pulling the feather boas and armbands off...

They can't look at each other...

WOODY takes agonised steps on her cut feet... finds her water bottle, nips a sip, then throws it to BEN.

WOODY: It's the other side of tomorrow Ben.

BEN: Please. Accelerate the knife. I can't pull it.

WOODY limps to BEN.

WOODY: My feet are fucked! What happened to us?

BEN: Please just... Please get it out.

WOODY pulls the knife and presses a pinny to the wound to staunch the blood. She is suddenly intimate and gentle.

BEN: Have you really forgotten everything?

WOODY: Of course. We took Forget. We had a whoosh time... Looks like things got a bit kinky... but its over now. Forgotten. We're still Special. Right?

BEN: Right.

WOODY: That's the whoosh thing about Forget.

BEN: Yeah...

BEN and WOODY make eye contact for the first time.

WOODY: Don't.

BEN: But I remember.

WOODY: No you don't.

BEN: I do. I remember everything.

WOODY: That's not proper.

BEN: Don't you talk about proper! I remember everything you said.

WOODY: Shut up. Don't say it. Don't.

BEN: You do remember then!

WOODY: We both said some stuff. None of that counts now. It's not our fault we got that Green.

BEN: She called it FuckU... I just wanted Forget. Just a night of smirk.

WOODY: We don't deserve this.

BEN: What are we going to do?

WOODY: We'll say we forgot.

BEN: Lie? But that's not Special.

WOODY: Please don't start. Let's just get home.

BEN: You're sure? We'll be OK?

WOODY: We'll go home, we'll be OK... If we can find the tags.

WOODY starts searching.

BEN: But we cut our way in. We can always cut our way back.

WOODY: No... The 7th wouldn't let that happen.

BEN: Did they 'let' us cut our way in?

WOODY: It's an Army thing... It's just a smirk...

BEN: I thought we were really being shot at!

WOODY: We were, but they only aim to maim on the way in. They miss nothing going back. Could be NonSpecs. See? So accelerate!

Silence

BEN: This is just fucking unbelievable! Unbelievable... I wish I'd never come here with you.

Silence

WOODY: Thanks.... Because... I'm so glad you're here too... Smirkless Fuck! We protect you from everything, so you can think things better, but you just spend your time whining like a

BEN: What? A NonSpec?

WOODY: Fuck you... I'd never... You know what I think of you... You know.

BEN: Amy

WOODY: Fuck you. Just search.

WOODY turns from BEN and searches... BEN dithers then joins in.. They find everything... apart from the tags.

Finally they both slowly turn towards the silk curtain.

WOODY takes a deep breath and runs through the curtain.

BEN: Can you see the tags... Woody?... Woody? Woody are they there?!

WOODY charges back through the curtain with the tags.

WOODY: Now let's go.

They put their tags on as WOODY heads to the door.

BEN: Was she alright?

WOODY: What?

BEN: Was Mrs M alright?

WOODY: No. She didn't look alright. She's dead.

BEN: Dead?

WOODY: Dead.

BEN: You're certain?

WOODY: The tags were round her neck, I got a good look.

BEN: You didn't check her pulse?... Woody?

WOODY: No.

BEN: Well don't you think you should?

WOODY: Why me?

BEN: Someone has too. You're used to doing things like that.

WOODY: And what would you know about what I'm used to doing?

BEN: I have permission to use my imagination.

WOODY: You have no idea...

BEN: But you will agree that it is a fact that you're more used to doing what ever you're used to doing than I am. So you should go and check her pulse. Go on! Specials have standards. If we don't uphold them where will we be?

WOODY: NonSpec's die everyday.

BEN: She saved our lives.

WOODY: I wasn't so impressed with the feet cutting.

BEN: Getting a knife in my arm wasn't much fun either.

WOODY: You always were her favourite!

BEN: I was not!

WOODY: You so were!

BEN: Well, I loved her at school. She always smelt nice. I remember when

WOODY: No more talk of illegal memories! What do they teach you at Uni!

BEN: I don't know.... I haven't been for three weeks...I can't face it.

Silence

WOODY: You're fucking with me?

BEN: No. I stopped going.

Silence

WOODY: Did they stop your health chews?

BEN: I told them I had a Big Thought coming and needed time off to think it through.

WOODY: But you haven't really?

BEN: No. I told you.

WOODY: But sooner or later, won't they want to know what your Big Thought is?

BEN: Yes.

Silence

WOODY: You spaztard!.... You'll have to try. You'll have to.

BEN: It's no use! I don't see anything good in my mirror anymore.

WOODY: I see the good. I do... We just need to get you back to the Special Zone.

BEN: But we can't leave without checking on Mrs M. If we leave without checking I'll know I'm nothing and then how can I go home and try to be an Extra Super Special?

MRS MASON, horribly beaten and bruised staggers through the silk curtain, unseen by WOODY or BEN.

WOODY: You have to forget about Mrs M.

BEN becomes aware of MRS MASON, who is now just standing, staring at them both.

WOODY: She's just another dead NonSpec!

Silence as WOODY realises MRS MASON is there.

MRS MASON: You were thinking of going without saying goodbye?

BEN: Of course not.

MRS MASON: I sense an untruth Benjamin!

BEN: Honestly.

WOODY: Ben. For fuck's sake, don't! Ignore her and accelerate.

MRS MASON: Amy Woodward you will wash your mouth out and never use that kind of language in my classroom again! Do you understand?

BEN: We're sorry Mrs Mason.

MRS MASON: Benjamin, silence and sit down!

BEN immediately sits down.

MRS MASON: I was talking to Amy. Wasn't I?.. Wasn't I!

WOODY: Yes.

MRS MASON: So what do you say?

WOODY: I'm very sorry for using a filth word in front of you Mrs Mason.

MRS MASON: Good girl! And it's forgotten already! Now sit down.

WOODY sits.

MRS MASON: So. You were going to leave without saying goodbye?

BEN: No. We were just getting our things together Mrs M.

MRS MASON: I see.

WOODY: Because it's almost the other side of tomorrow.

BEN: We have to go home. Our tags are running out.

MRS MASON: Home... Yes, I see darlings... Only there are hours before then. Hours. Maybe you should wait?

WOODY gets up.

WOODY: No. We do have to go. I'm sorry.

MRS MASON: But Ben? Won't you stay? Because we've so much to catch up on! I'd love to hear your news. Doing well for yourselves? Like Tim? Do you see Tim?

BEN: No really. I think we do have to go.

MRS MASON: Or we don't have to chat. We don't... There are other things...If you like. Because... I know what we could do! Goodness yes, we could do a little combo?

WOODY: What?

MRS MASON: Don't be bashful darling! I don't mind! We can do whatever you like. All three of us. Endless Combos... I can show you both a marvelous time... For a health chew or two?

WOODY: Queertarded sex is a waste of moisture and is not proper.

MRS MASON: Or not. As you wish. We could just chat of course! Only stay. Please?

WOODY: Only Extra Specials may come for a baby. Only Specials may wet yank monthly. MultiMums and Queertards are NonSpec.

MRS MASON: Darling, I was reading the Special's Handbook long before you were even born.

WOODY: Well do not discuss proven things when proven things are not to be discussed then!

MRS MASON: But some proven things turn out to be wrong. I've found... Since coming here.

WOODY: Lies.

MRS MASON: Last night I'm sure you weren't thinking about wasting moisture.

WOODY: I don't remember. I don't remember anything. I am Special.

MRS MASON: Amy darling, you're a terrible liar! You always were.

WOODY: The only liar here is you!.. Traitor NonSpec whore... You want to know something straight up? Yeah? Yeah? Everyone hated Tim at School. Everyone.

MRS MASON: Hated Tim?

BEN: Mrs M. Amy didn't mean what she just said... She didn't mean it... Did you Woody?

MRS MASON: Everyone loves Tim. Don't they?

BEN: Everyone loves Tim, Mrs M. Everyone.

WOODY: Tim was a shit behind your back. We all just loved you! But then you lied and went all wrong and NonSpec. You let us down...

BEN: Amy, shut up and give her a health chew.

WOODY: No.

BEN: She's not a NonSpec. Not really. She's Mrs M. Look at her! Look at her! She needs food. Do you really think she's a traitor? Really Woody?

WOODY: I don't know.

BEN: Do you believe that I am an Extra Super Special?

WOODY: You don't... You know I do.

BEN: Then I am ordering you to look at her and tell me who you see... Look at her! Tell me!

WOODY: I see Mrs M. Alright? But that's not proper. Ben, we have to go.

MRS MASON: But you must tell me how Tim is. I love him so much. So much. So much. I slate him and slate him, but he never writes back. Never. Why wouldn't he?

Silence

BEN: It's because he hasn't got your address. He probably never got your letters. If he had that he would write. He would. I know Tim and I know he would write.

Silence

BEN: Letters get lost. Sometimes they get lost. Don't they Amy?

WOODY: What are you doing?

BEN: Don't they Amy?... Amy?

WOODY: If you say so Ben... Sometimes slates get lost.

BEN: You see Mrs M?! Maybe... Listen... Maybe you could slate Tim a letter and we could carry it for you... When we get home we could take it to him. Hand it to him.

MRS MASON: You would do that Benjamin? For me?

BEN: We'll do that for you. It's what we can do.

WOODY: We cannot carry post for a Non Spec even if she's a good one like Mrs M.

MRS MASON: Darlings! Darlings! This is wonderful! You are wonderful!

WOODY: No. Listen to me. Both of you. No. We're not carrying that slate.

BEN: We are. We're taking it.

WOODY: No! Here. Here! Take these.

WOODY hands MRS MASON three chews.

WOODY: That's all we can do for you.

MRS MASON: Three bars! Three! Oh but that is so kind. So generous! We must celebrate!

WOODY: No. Listen!

MRS MASON: I shall use the chews to bake for us! And you must help! But first! Aprons on!

MRS MASON gives BEN a pinny and he puts it on. She gives one to WOODY.

WOODY: No.

MRS MASON: And then I shall write my letter. After we have baked.

WOODY: We're leaving.

MRS MASON: And you will take it for me?

WOODY: We can't help you.

MRS MASON: Because Ben promised, and a promise is a promise... Ben?

BEN: I'm sorry! Woody says no. We can't.

WOODY: We can't...

MRS MASON: You can't?

BEN: Woody says no. It's too dangerous.

Silence

MRS MASON: But I have something. I have something I know you will want. We can do a swap! Will you look? You'll change your mind when you look. Ben?

WOODY: Ben. I can't stay here.

MRS MASON: Please, let me show you. Ben? Ben? Please? Ask Amy. Ben? Will you?

BEN: Woody? Can we? Can we just look? For Mrs M?

MRS MASON: Because. I have something.

WOODY: Alright!.. 15 minutes. No tardy.

SCENE 8 - MRS MASON'S BASEMENT - MORNING

MRS MASON goes to her bookcase, pulls it and it swings free, revealing a secret cupboard behind the false wall.

MRS MASON: Darling! Come along! These are friends! Special Friends! Come and say hello!

MERT (19, African, stunning but painfully thin, dressed just like MRS MASON) walks from the cupboard.

MRS MASON: May I introduce Mert, my new daughter.

MERT: How did you do?

BEN and WOODY just stare, stare, stare.

MRS MASON: Mert my dear, you must try harder.

MERT: How did

MRS MASON: Do!

MERT: How do you very do?

MRS MASON: Perfect! Perfect! Isn't she Ben? Isn't she perfect?

BEN just stares.

MRS MASON: Now Mert my girl. Would you be so very kind as to give Benjamin the time of his life? If you do, he has promised to take a letter to Timothy!

BEN: No! I said I would look, but

MERT: For Tim! Oh but this is very fine! This is a good heart. A good heart.

MERT goes and takes BEN by the hand and starts to pull him towards the cupboard...

MRS MASON: Because you are the very most precious gift I could give him. The most precious.

WOODY: Wait!

MRS MASON: You can join them if you want Amy, I just assumed from what you said earlier that

WOODY: That is enough. Don't. Stop touching him. Stop.

MERT begins to whisper unheard things in BEN's ear.

WOODY draws her pistol and points it at MERT.

WOODY: Let go of him.

MERT immediately lets go of BEN. WOODY continues to point the pistol at her...

WOODY: You're black aren't you?

MRS MASON: No dear. Spanish. Dusky yes but certainly legitimate and Euro through and through.

WOODY: Illegal, ZeroSpec... Black filth... You are arrested. You will kneel down.

MERT: I kneel for no one unless I am choosing this.

WOODY slides the safety off her pistol.

BEN: Woody! Think?

WOODY: I am doing my job. She is ZeroSpec. She is here illegally.

MRS MASON: You don't know that. You don't know that.

WOODY: I can smell it on her.

BEN: But what if you're wrong? You must do the slate work. It will not be proper.

Silence

WOODY: Jesus... Mrs M, do you have a spare slate that I could borrow?

MRS MASON: Amy I'm afraid that I only have one, and I need that to write to Tim.

WOODY brings the pistol down and looks at BEN.

WOODY: Do you want to fuck her?

BEN: No!

WOODY: You do! You want to fuck her but you don't want me.

BEN: Please calm down.

WOODY: Why? What's wrong with me?

BEN: There's nothing... You know... You're not an Extra Super Special.

WOODY: And a filthy ZeroSpec is better?

MERT: If I have to choose between you and me, I know who I am choosing, bitch.

WOODY brings her pistol back up.

MRS MASON: Amy and Mert, we will both talk nicely or not at all.

BEN: Woody! Let's just calm down and talk. Ok?

WOODY: If you wanted me I could apply for Subsidiary Extra Special Status.

BEN: But we're friends. Just friends.

WOODY: Why? Every man I know wants to fuck me apart from you.

BEN: I don't know. I can't change it Amy.

WOODY: Everyone else thinks we should be together.

MRS MASON: Really! I always thought you and Tim would be far better suited.

WOODY/BEN: Shut up!

BEN: I never promised you anything.

WOODY: But you knew I hoped... You knew... Fucking coward...You're no man...

BEN: Woody don't.

WOODY: "Woody I'm frightened I may be a NonSpec"

BEN: Shut up.

WOODY: "I can't face Uni anymore and I haven't done my homework"

BEN: I mean it. Shut up.

WOODY: Fucking idiot, spoilt queertarded nancy boy. When people only half as good as you are dying to protect you. Would die to protect you. Would give you everything.

BEN: I am an Extra Super Special! You of all people will not question my place on the list.

WOODY: I never said anything about the list Ben!.. Have I gone and hit a nerve?

BEN snaps... Livid. WOODY steps back from him.

BEN: Ever since you got back... you're like... I feel sick...Who's she going to dry off ? Push too far? Accelerating. Never still. You're too much.

WOODY: I was just smirking. I always see you right. Water, my health chews. Everything for you!

BEN: No. You're like a weight. When I've no energy... And I don't love you.

BEN takes WOODY's pistol from her.

BEN: And you know what else? I do just want to fuck her. For no other reason than that she isn't you. Understand? I'm no queertard. Come and watch, be my guest. Then fuck off.

BEN starts to drag MERT away.

WOODY: You go in there, I'll leave you here... You'll never get back without me.

BEN: I have my tag. Once I show them my mirror at the gate, I don't think anyone will be shooting at me, do you?

BEN pushes MERT into the cupboard.

WOODY: Fine. Fuck her then. Fuck her. Be a man with a ZeroSpec... Go ahead.

Silence.

MRS MASON takes a slate and begins to write.

MRS MASON: Darling, there is plenty more plastic in the sea.

WOODY begins to gently shake, staring at the cupboard.

MRS MASON: You were such a sunny child. I shall remember you as you were.

MRS MASON keeps writing. WOODY just shakes.

WOODY: For the last six months I've put my life on the line every day, defending the Eurozone from ZeroSpec scum. Only it turns out you've got one right here in your fucking cupboard!

MRS MASON: But mainly you're enjoying it? Your work? Because it's a rewarding career isn't it?

WOODY: Did you hear me?

MRS MASON: I hear everything my darling but I have made it a golden rule only to listen to nice things.

WOODY: If I had the slate work I'd postpone her like that!

MRS MASON: Amy, stop trying to show off. You are not a murderer.

WOODY: It is postponing.

MRS MASON: I doubt the Postponed would see it like that.

WOODY: They are ZeroSpec. They don't feel like humans do.

MRS MASON: Goodness! Next you'll be telling me NonSpecs aren't human either.

WOODY: No.

MRS MASON: Well that is a relief.

WOODY: They're half human... I'm sorry... I'm not sorry, but I am sorry that you're one of them... But there's no more time to waste...Difficult decisions have to be taken.

MRS MASON: I'm sure you're right Amy.

WOODY: You'd have us waste everything on NonSpecs and ZeroSpecs when Extra Super Special Babies are dying?

MRS MASON: Oh I love babies Amy. And not to eat! Goodness no! I think everyone is special. Everyone. But now, could you pedal a little? I must get this letter written for Tim.

Silence.

MRS MASON: Darling! Beatings play havoc with my eyes! I simply can't see a thing in this light.

WOODY gets on the bike, starts to pedal and the lights and music start up.

MRS MASON: Thanks so much. Now you were saying? About the situation? That's right! The awful decisions that have to be made and how it's hurting you more than it's hurting me?

WOODY: Yes.

MRS MASON: Well do go on. Go on.

WOODY: It's not proper for me to be talking to you.

MRS MASON: As you wish...

WOODY: But you're wrong. Everyone can't be Special. Only people like me... me and him are.

MRS MASON just writes... WOODY starts to pedal faster...

WOODY: For him... I was. Am... I'm protecting our way of life. I'm protecting our future.

WOODY's pedalling starts to go ballistic...

WOODY: What would you do? What?... Is it wrong for me to protect what is left?

WOODY stops pedalling.

WOODY: What is left... Was I? Was I? I can't be wrong.

MRS MASON: I'm sure you're right. Only. There's one thing that puzzles me dear... If you are so special and I am nothing, why do you come into my ghetto to take 'Forget'?

Silence.

MRS MASON: Why Amy? What are all the Special tourists ghetto-jumping for?

Silence.

MRS MASON: Amy darling? I would love to understand, because all I dream about is going home.

WOODY very quietly begins to sob...

MRS MASON: Oh but I didn't mean to make you cry!

MRS MASON rushes to put her arms around WOODY.

WOODY: I can't sleep Mrs M. I can't sleep. I can't close my eyes.

MRS MASON: Shh now.

WOODY: Don't think, don't think about it. But at night there's nothing else.

MRS MASON: Amy? If I held a little party would that cheer you up?

WOODY: Remember who you're fighting for. But he's not interested... and now you say we're all Special... What if you're right? It can only get worse. If we are. Are we? Really?

MRS MASON: Oh yes my darling. We are all very very special. Every single one of us.

As WOODY cries in MRS MASON's arms, the basement...

SCENE 9 - INSIDE THE CUPBOARD - MORNING

...morphs into the cupboard... WOODY and MRS MASON disappear and BEN and MERT are discovered.

BEN is struggling to have sex with MERT. He keeps looking over his shoulder...

MERT: And then the bastard took my money but has no tag for me! After all the promises. 'A new life! Things grow in the EuroZone!' I trusted him! But when I wake up I am here.

BEN: Right... Look can you just?

MERT: Oh!

MERT starts to move more vigorously.

MERT: I decide to die. But this is when my Mrs Mason finds me and takes me here to my new home and dreams me lamb kofta and it is so real.

BEN: Mert, do you think

MERT: You want to hear of fish and chips? Everyone is wanting this.

BEN: I just need you to

MERT: Or Pizza! Tomato, herbs and crust. I am learning to make beautiful sawdust crust. My dream is to visit with Mr Ackroyd... But I am forgetting the cheese. And now the black pepper, grinding, over the cheese. Coming all over the cheese. Oh it is so good... So

BEN: Jesus Christ! Shut up!

BEN rolls away and sits with his head in his hands.

Silence.

MERT: My cunt must be yours but my voice is mine to speak.

Silence.

MERT: Do you hear me Special Boy?

BEN: Yes.

MERT: What is so very wrong?

BEN: I can't talk to a ZeroSpec

MERT: But you may fuck me?

BEN: I can't even manage that.

BEN looks over his shoulder again, fearful.

MERT: She will not come to watch. She is loving you. How would she?

BEN: Then we don't need to do this.

MERT: But yes we must. I promise my Mrs Mason. You will have a good time.

BEN: But I can't.

MERT: You must try harder. A promise is a promise.

BEN: Would it count if I yank myself?

MERT: This is alright. Yes. You must only come, that is the bargain.

BEN: Fine.

BEN starts to masturbate.

MERT: But this is not working for you either... Benjamin, really, this is no good.

BEN stops and sits dejected.

MERT: I see the problem. Your friend is right! You are needing a cock up your arsehole I think?

BEN: What? No! I like girls

MERT: No. You do not like girls Benjamin. I see many men who want girls. You want cock. It is alright! I am only

thinking of girls when men are coming with me. You are the same I think? You're heart is for men no?

BEN: No!

MERT: No? That I am for girls or you are for boys? You are not so very clear.

BEN: I'm no queertard. I'm proper.

MERT: Proper, proper, all I hear is bloody proper! It is all shit this proper.

BEN: Wrong. Proper is perfect.

MERT: I know what I see.

BEN: I am an Extra Super Special and I see everything as it is.

MERT: Apart from what you are missing and I am seeing.

BEN: You are not seeing anything.

MERT: I am seeing a limp cock sad boy who lies to himself and wishes he could fuck boys, boys, boys but is too scared to break his stupid rules.

BEN: Wrong, wrong, wrong, wrong, wrong!

MERT: Right.

BEN: Wrong.

MERT: Whatever.

BEN: Whatever? No! No! It is not whatever! No. As it happens Miss Zero Spec know-it-all! You see nothing and know fuck all. Nothing. I don't get hard because I have no heart for it. Because I love a girl. Because I love her and I wish I didn't.

MERT: Whoosh! Really?

BEN: Really!

MERT: Well this I have not seen before. I am usually so right about these things.

BEN: Not this time. Not about me.

BEN zips himself up. MERT takes his hand.

MERT: What is this very clever girl's name?

BEN: I can't talk about her.

MERT: Oh come on. If you tell me, some stupid ZeroSpec, I do not even count so you have not said it. Yes? It is like you have only spoken with yourself.

BEN: Why?

MERT: Love is very precious Benjamin. I miss my girl. So tell me of yours.

Silence.

BEN: Well, she's called Mary.

MERT: She must be so very good to fuck yes?

BEN: We make love.

MERT: Of course! Only, sometimes a girl that loves you still likes to be fucked Ben, you should know this.

BEN: For someone who is not here, you're very good at interrupting.

MERT puts her fingers to her lips.

BEN: Anyway, I love her but it is not possible.

MERT: Because?

BEN: I can't say.

Silence.

MERT: This is that?

BEN: Yes.

Silence.

MERT: This is not so the very best love story I have ever heard Benjamin.

BEN: She is a HalfSpec. It's wrong.

MERT: But no! It is right. This is how I felt about my girl back home.

BEN: It's not the same.

MERT: It is the same.

Silence.

MERT: This is very bad.

BEN: I know.

MERT: Because you love this Half Mary and so you can not fuck me, even though I have to tell you I am very good at it and you are missing out very much. Even so, now you will not take this letter and Mrs Mason is so very sad without her Tim.

BEN: I was talking about Mary.

MERT: Only, with your big heart? You may be a special Special not a bastard cunt special like so many I have met? Maybe you will help her anyway?

BEN: I am not so good. Not so good.

MERT: No you have a heart. I see this now.

This is too much for BEN. He covers his face.

BEN: Mary is spawning. We have no permission but she won't get it cut out. She says she loves it.

MERT: But you must make her.

BEN: It's too late, she's already beginning to lump.

MERT: So now you must run, yes?

BEN: I am an Extra Super Special... I cannot spawn with a HalfSpec. It is not proper.

MERT: There you go with your bloody proper again.

BEN: It is my duty to make the world a better place.

MERT: Yes. Of course. You are doing such a very good job with this so far.

Silence.

BEN: I shouldn't have said anything.

MERT: You worry what I am thinking now?! But really! You know something? I do not care about your sad love story. You all want to talk, so I let you. I am here only for Mrs M.

BEN: Will you tell?

MERT: Will you be taking the slate Benjamin?

BEN: I want to help. I want to...

MERT: Then we see. Yes?... We see...

BEN quite suddenly kisses MERT on the cheek.

MERT: It is ones like you who mean so well but will end up doing so the very worst things... This make you smile? Why? I am not meaning to be kind.

BEN: I'm meant to be the big brains with the mirror.

MRS MASON: *(Off.)* Benjamin! Benjamin! Oh but darling please help! Help darling! Help!

SCENE 10 - MRS MASON'S BASEMENT - MORNING

BEN and MERT rush as the scene morphs around them and they are back in MRS MASON's basement where they discover WOODY on the floor and MRS MASON madly blending sawdust while pedalling her bike...

WOODY: So terrible.

MRS MASON stops blending and tests the sawdust.

MRS MASON: FuckU turns out to be a horribly blue come down darlings!

WOODY: Terrible.

MRS MASON: I have tried tea. I had to use the last of the water on her.

BEN: It was our water!

MERT: Oh Mrs M! No!

MRS MASON: Mert darling, but what could I do? She is a friend of Tim's after all.

MERT: But I am too dry to help.

MRS MASON: Well, I'm sure Ben won't mind having a little pee in our bottle will you Ben?

BEN: I'm dry too.

MRS MASON hands BEN a bottle... BEN unzips himself.

WOODY: Terrible things.

MERT: And you have tried your memories of roast beef and Yorkshire puddings?

MRS MASON: Of course child!

MRS MASON takes the dribble of pee from BEN and adds it to the blender then gives it a blast.

MRS MASON: She's having an emergency Benjamin. You must use your Extra Super Special talents upon her darling and make her shine like new.

BEN: We fell out... Mrs M? Remember? I'm not sure I'm the best person?

WOODY: So terrible.

MRS MASON starts crashing around looking for a baking tray.

MRS MASON: Just do your best. That's all we can do isn't it? Our best.

BEN kneels by WOODY and takes his mirror out.

BEN: I see my perfection and in seeing it I see what you see and...

WOODY curls up.

BEN: In a better day we reach my potential.

MRS MASON: Listen and learn Mert dear. Just super diction.

BEN: Life's never been better... Woody! You know this is not permitted.

WOODY just curls tighter into a ball.

BEN: Mrs Mason is baking for you Woody!

MRS MASON: Mrs M's famous sawdust surprise no less!

WOODY: I don't deserve sawdust surprise.

MRS MASON: You do. Yes! Of course you do! Of course you do! Doesn't she Ben?

BEN: Yes of course.

WOODY: But I may have done something terrible.

BEN: The soft tags and the whole border control thing was way out of order. But I've done things too... And I shouldn't have shouted...

WOODY: Terrible.

BEN: Woody! Stop acting like a NonSpec and pull yourself together.

MERT: This is very hopeless.

BEN: Because it's the other side of tomorrow already.

MRS MASON: Oh don't worry about that! I don't mind if you stay longer.

BEN: But I do mind. So you need to stop this and start remembering you're from the 8th and a Special Zone hero because we need to go home.

MERT: She is 8th?

MRS MASON is now putting the finishing touches to the sawdust surprise that she is smoothing into a baking tin.

MRS MASON: Hands up who wants to help with the decorating?

MERT: She is 8th?

BEN: Yes she is 8th!... Woody? Remember who you are!

MERT: Oh I am very able to help with this I think.

MERT takes a cooking knife and lunges at WOODY... But misses and ends up stabbing BEN in the opposite arm to the one that was stabbed before.

BEN: Aaaaaaaaaah Fuck! What are you doing?

MRS MASON: Mert! Did you do that on purpose?

MERT: She is a scum shit and should die.

BEN: Get it out. Just. Get it... Please!

WOODY just lies there curled up.

BEN is hopping around screaming.

MERT gets a new knife and calmly walks towards WOODY.

MRS MASON: Everyone! Mrs M must ask for instant quiet and calm!

WOODY: Terrible things. I'm sorry.

MERT grabs WOODY's hair and pulls her onto her knees.

MRS MASON: Mert, really now, that is enough dear.

MERT puts the knife up to WOODY's throat.

MRS MASON: Right! Silent statues now!

MERT, WOODY and BEN freeze.

MRS MASON: If I see so much as a hair on the top of anyone's head move so help me, you will all be in detention for the rest of the week...

MRS MASON rips the knife out of BEN's arm.

BEN: Awwwwwh!

MRS MASON clips him round the ear as she moves to loom over MERT and WOODY.

MRS MASON: Mert, give me the knife.

MERT: No

MRS MASON: Drop the knife.

MERT: No.

MRS MASON: I am going to count to three and then you will give me that knife. One!

WOODY: I didn't know ZeroSpecs were people.

MRS MASON: Two!

MERT: You are shit scum

MRS MASON: Three! Watch your language madam and drop it, now!

MERT drags WOODY to her feet and squeezes the knife even closer to her neck.

MERT: She is the 8th and I will kill her.

BEN: The 8th are heros.

MRS MASON: Benjamin! Did I say that you could speak?

BEN: I was just

MRS MASON: Well don't!.. Mert we must learn a new word. It is 'consequence'.

MERT: I understand this very well.

MRS MASON: Marvellous dear, you're studies are coming on.

MERT: I do not care of this consequence.

MRS MASON: About!

MERT: About them. It will be worth it.

MRS MASON: Excellent! Only no, understand, it will not! It will lead to ghastly things.

MERT: For once you could understand.

MRS MASON: Mert?

MERT: For once. For once you will listen and you will hear. You will hear... When I run from my home. Everyone is dying or running. This is all there is. My girl and I go as sisters. Everyone says Eurozone. This is the place. Only get there.

WOODY: They come on their shit filled boats. Hundreds of boats. Always coming.

MERT: I don't know how long we float. No water and no shelter from the sun. Many people were dying.

WOODY: They don't land in daylight. They take their chances at night.

MERT: It was darkness. All quiet, but then

WOODY: I take over the watch and I ask my sergeant 'Are you ready to fuck the scum?'

MERT: Bullets and bullets and everywhere screaming. The sea is in my air. My girl is nowhere.

WOODY: We stand on the sand and we fire.

MERT: I see a boy, his face goes missing and then he sinks.

WOODY: But there are hundreds who make it.

MERT: There is nowhere to go but towards them.

WOODY: I shout to the new boys 'Fuck them slow and steady'.

MERT: I reach the sand and I am screaming for my girl. I run and there is a boy and his gun is jammed and I run then. I forget her for running. How did I forget her?

WOODY: We fuck the scum and the Specials stay safe.

MERT: I spend the night hiding.

WOODY: We spend the night on round up.

MERT: I watch as the sun comes up.

WOODY: The fittest dig.

MERT: I can not believe what I see.

WOODY: We make them lie in the pits on top of each other.

MERT: I see my girl. She lies down on top of another... She does not struggle.

WOODY: They piss themselves as they lie there. Waste.

MERT: I don't know why she does not try and run. Please run!

WOODY: We keep on until the pits are full.

MERT: And now they walk, shoot, walk and shoot into the pit, walk and shoot again and again

WOODY: If you line it up right you can fuck three layers with one slot. This is good. We fuck scum and make no waste. We are the 8th.

Silence.

BEN: I don't believe you.

WOODY: Because they are not people.

MERT: And I cannot believe what I am seeing. I hide. I lie still. I cannot move.

WOODY: This is my work.

MERT: And I cannot believe what I am seeing.

BEN: I don't believe you.

MERT: And when you tell people what you have seen they do not believe you

WOODY: And what has happened? Postponement. No one has died.

MERT: Until you are wondering if you did see what you saw? So you no longer say.

WOODY: But if they are people? If it turns out they are people. Then what?

BEN clutches at his mirror.

BEN: ZeroSpec and NonSpec are not people.

WOODY: But you said Mrs Mason was not a NonSpec!

BEN: Mistakes are sometimes made.

WOODY: So Mrs Mason is Special! And she has told me Mert is a person.

BEN: We have no slate work. We don't know what Mert is.

MERT: Mrs Mason?

WOODY: Mrs M says Mert is a person Ben. She must be someone.

BEN: Stop it.

WOODY: You wanted her when you could have had me. She must be someone.

BEN: NonSpecs and ZeroSpecs cannot be people.

WOODY: But what if they are? What if they really are people? Then, what have I done?

BEN: You are a hero.

MERT: Mrs Mason? Did you hear?

WOODY: So then I'm thinking thinking. I can't stop thinking. Maybe I am NonSpec? But then I am thinking! No! This is not possible. I am Special. Everyone says so.

BEN: Of course you are!

WOODY: But if I am Special but the same as the ZeroSpecs, then they must be Special too.

BEN: Woody. You've gone mad.

WOODY: But what if it is true? What if we're all just Special. All of us?

MERT: Mrs M?

BEN turns away with his mirror...

MRS MASON: Well my goodness! We have all learnt some new things and heard some new ideas that I'm sure we will all be thinking about for quite sometime to come. Yes quite some time.

MERT: Did you hear? Did you hear me?

MRS MASON: Yes Mert darling, I heard every word.

MERT: So I may now kill her please?.. May I please?

MRS MASON takes a little bell and rings it.

MRS MASON: Only, there is the bell!.. What does the bell mean Mert?.. Mert?

MERT: That it is time to open the oven door.

MRS MASON: It is time to open the oven door!.. Of course we must imagine the oven, because we do not have one, but what we do have is a very special sawdust surprise! And it is ready!

MERT: You did not hear.

MRS MASON: Everyone! Wouldn't everything just be better if we took a moment to have Mrs M's sawdust surprise?

MERT: You never hear.

MRS MASON: Yes it would Mrs M!... Good! So now, Mert will put down her knife, Ben and Amy will take my letter for Tim and Mert will remember that the way to make them pay is to live! To breathe their air and live. This cuts them! Far deeper than any silly knife.

MRS MASON starts to slice her sawdust surprise.

MERT: This is you finished with words? They will kill my girl but their air is all I may have? Is your Tim and your letter so much more important than me?

MRS MASON stops cutting and looks up at MERT...

Suddenly, WOODY, with a precise ease disarms MERT and throws her to the floor and now stands with the knife.

BEN: Thank God! You're back! Woody's back!

MRS MASON throws herself between MERT and WOODY.

WOODY: We're not taking your letter. Mrs M, you're going to deliver it. And Mert's going with you. Both of you. To the Special Zone. If we are all Special, we must all go home.

WOODY gives the knife back to MERT.

BEN: Why do you keep doing that? Why?

MRS MASON: Mert! We're going home darling!

MERT: You are fucking with us?

WOODY: I am not fucking with you.

MRS MASON: Since I am in a holiday mood I shall let these little filth words go.

WOODY: I want to be clean.

MRS MASON: But only this once!

MERT: You will never be clean.

MRS MASON: Because we are going home! My darling girl!

BEN: Hello! Ben to nuts girl Woody!

WOODY: I didn't know.

MRS MASON: Home! To the Special Zone where we belong.

MERT: I think you know. I think so.

BEN: What just happened?

MERT: You will never be clean.

> *MERT turns to MRS MASON. The two women hug.*

> *MRS MASON starts twirling around with her sawdust surprise, offering it to everyone.*

> *WOODY moves towards her. MRS MASON hugs her.*

BEN: Listen to me! If Specials allowed everyone Special status then how would we know who to feed? Things can only work if we keep the rules.

WOODY: Or we could change them.

BEN: Of course. Yes, lets just change the rules. That's how the world works Woody!

> *BEN looks into his mirror.*

BEN: We must have rules... Because... But that's the key!.. The rules... Not the thinking.

WOODY: But if the rules aren't proper?

BEN: The thinking is the problem! It is the rules that count, nothing else... No more time for thought... Fuck! I'm thinking big! My big thought! It's here! I can feel it coming!

WOODY: Ben?

BEN: To think too much is clearly NonSpec! The mirror has shown me this.

WOODY: Ben, you just made that up!

BEN: No! The mirror spoke. It has spoken.

WOODY: I don't believe you. Let me have a look!

WOODY snatches the mirror...

BEN: Don't. You're not qualified...

WOODY ignores BEN and gazes into it...

WOODY: There's nothing there!.. Just a... Is that me? God... That can't be me!.. Is this me?

MERT and MRS MASON, tentative, circle in and peer too...

BEN: Don't! It isn't proper. You mustn't look.

MRS MASON: The last time I looked I was sweet 16... Oh and I haven't changed one bit! Ciao! Bella!

MERT: But I am looking like all the dead ones. Look! How is this happening to me?

BEN: Get off it! You insult the mirror!.. You are lost... I denounce you. All of you.

Silence

MRS MASON: You wouldn't... Don't spoil it Ben. Not when we're all going home and

MERT: He will not fuck with us. He has his half Mary and his hands very full.

BEN: Half who?.. Who's Mary?

MERT: I told you! You fuck with me, I will speak.

MRS MASON: Mert! However provoking, you simply must stop threatening the house guests.

BEN: They wouldn't believe you.

MERT: You have a mark on your cock which is not so easy to forget Ben. They will believe me.

BEN snaps and takes WOODY's pistol from his belt, points it at MERT and wills himself to shoot...

WOODY: Ben... If you shoot her, I'll smash your mirror. Alright? Just stop.

WOODY holds the mirror out towards BEN...

BEN moves to WOODY. They swap the mirror and pistol...

WOODY suddenly puts her arms around BEN. They embrace for an instant. Then BEN pushes her away and runs from the room.

WOODY crumples, disappears, as the basement dissolves..

SCENE 11 - BORDER FENCE - MORNING

... Into The Ghetto... MERT and MRS MASON are running, running... Until they reach the Border Fence...

The SOUNDS of The Ghetto are intense again. Screaming, music, shouting; a cacophony of desperation...

MERT paces as the Sun rises over The Ghetto...

MERT: She is not coming...

MRS MASON: She is coming. Of course she is coming.

MERT: She isn't coming.

MRS MASON: I know she is coming... Let's practice your lines.

MRS MASON and MERT pace, waiting as the sun travels high in the sky.

MRS MASON clings to the fence.

MERT: She is not coming...

MRS MASON: She is coming. Of course she is coming.

MERT: You should have let me kill her.

MRS MASON and MERT are waiting, waiting, as the sun sets over the Ghetto Zone...

MRS MASON finally slumps down.

MRS MASON: Tim will be so wonderfully surprised. So surprised. What will he say Mert? Darling? What will he say when he sees me and I hand him his letter!.. Mert darling?

MERT: I don't know.

MRS MASON: He will say, I have missed you so much. I have missed you everyday.

MERT: Mother, she is not coming.

MRS MASON on the brink of losing hope, looks up...

MRS MASON: But look?

WOODY, covered in fresh gore, moves towards them. She holds three blood stained tags. She is shaking.

MRS MASON: I knew she would come.

MERT: You are very late.

MRS MASON: Oh no! We have only been waiting a moment. We hardly noticed a thing.

MERT: Where have you been?

MRS MASON: Darling, she is here now.

WOODY: It was hard... The tag from the Spanish sector is rare here. The boy was very young.

MERT: You would not struggle with this.

MRS MASON: But goodness Amy? Did you steal the tags?

WOODY: You know I did.

MRS MASON: No darling. I would never have agreed to that. We do not steal!

MRS MASON spits on a hanky and cleans WOODY's face.

MRS MASON: Never mind. We shall never think of it. It's forgotten already.

Silence

MRS MASON: Now Mert, would you like to show Amy your homework? She's very good. Very convincing... Mert? Come along...

MERT: Hello, and a very good day to you sir.

MRS MASON: Name?

MERT: Ana Martínez Botella

MRS MASON: That is a simply delightful name. May I have your tags please Senorita?

MERT begrudgingly mimes giving MRS MASON her tag.

MERT: I think you will find them all proper and certainly in order.

MRS MASON: Reason for travel?

MERT: The famous pies of Mr Ackroyd of course...

MRS MASON: See! Amy? Isn't she marvellous?

Silence.

WOODY: Mrs M, have you ever even heard a Spanish accent?

Silence

WOODY: Jesus... We're fucked... We'll never get through the gate...

MRS MASON: Oh I'm sure we will. I'm sure we'll be just fine my darling.

MERT: She is never intending to take me. Never.

Silence

WOODY very reluctantly pulls out her wire cutters.

WOODY: You two had better be ready to

SCENE 12 - NO MAN'S LAND - NIGHT

MRS MASON, MERT and WOODY run as the scene around them morphs into the broken world of No Man's Land.

The SOUND of clockwork cranks and ticks and tocks.

The search lights zip and slash.

The guns fire as WOODY, MERT and MRS MASON lunge and slip and slide through the shadows, dodging the light.

The group gets stuck. Trapped as bullets fly...

The clockwork winds down. The search lights flicker

WOODY: RUN!

DARKNESS. The SOUND of cranking clockwork and raging gunfire.

The search lights come back up. MERT is alone. She has not moved.

WOODY comes crawling back into view.

MERT: I can't. I can't. I can't.

WOODY: How are you going to breathe my air and drink my water sitting there?

MERT: Fuck you.

WOODY runs out into the middle of No Man's Land

WOODY: Hey over here! You cannot touch me. I'm the 8th.

WOODY starts firing.

WOODY: Mert! Now!

MERT runs and makes it to the safety of shadows just as

WOODY is hit.... She falls into shadow and is gone.

And then slowly the sounds of clockwork and guns and far off screaming and the cacophony of horror fades

Until there is nothing but DARKNESS...

SCENE 13 - THE SPECIAL ZONE - EARLY MORNING

OUT OF THE DARKNESS...

The SOUND of: A warped version of Beethoven's Pastoral Symphony (No 6 In F) Part 1 over a tannoy.

As a new day slowly dawns...

To reveal a world of desiccated, neat, dry, order.

Piles and piles of broken but neatly stacked stuff. Fridges, TV's, computers, shoes, plates... But no life.

MERT and MRS MASON stagger through this world.

MERT, bewildered, devastated, exhausted... MRS MASON delighted, skipping in a brittle kind of ecstasy.

They both clutch pastry pies

MERT: Where is everyone?

MRS MASON: It is hard for us to bear, but we must acknowledge Amy has gone.

MERT: I do not mean her. Where is the life?

MRS MASON: She was so brave, but we must move on. We must, for her sake and ours.

MERT: I will not be sad for her. I will not.

MRS MASON: Otherwise, she will have died in vain darling.

MERT: Where is the life. Why does everyone hide away?

MRS MASON: I shall make a trifle. Yes and I shall call it 'Amy's terrific trifle' and every year I will eat it with you and Tim and we shall remember her as she was.

MERT: I will choke on it before I eat this. I do not forgive her.

MRS MASON: A sunny, happy, brave young hero.

MERT: You are not listening or seeing? You must look.

MRS MASON: I will not let anything spoil our Special day... So what shall we do with ourselves next young lady?

MERT: It is no good. I love you but this is no good.

MRS MASON: It is fine darling. It is very fine. What shall we do next?

Silence

MERT: It is no good. Where is Tim?

MRS MASON: Don't spoil things please.

MERT: It is not me spoiling things. Where is Tim?... Why is there only dust pasties at Mr Akroyd's pie shop?

MRS MASON: Didn't you see? It is now 'Mr Akroyd's Pie Emporium'! Progress, Mert, is wonderful.

MERT: His pies are very bad. Nothing to your sawdust surprise.

MRS MASON: Well I am enjoying mine.

MRS MASON takes a deliberate hearty bite out of her pie which now starts to ooze sand.

MRS MASON: If you would just try, you might enjoy yours too.

MERT: Where are the very special shops with the pretty clothes?... Where is the rabbit animals with the pink eyes who you may pet as well as eat?.. Where is the water tanks full of very fine clear water?

MRS MASON: Do not panic my girl! Tim will know what to do... Once we find him... I'm sure our house used to be on this street... I'm sure there were houses here...

MRS MASON takes her slate and looks at it.

MRS MASON: I don't know where to post it.

MERT: Mrs Mason?

MRS MASON: I had so wanted to hand it to him.

MERT: Mrs M?

MRS MASON: I don't know where to find Tim.

MERT: I'm so sorry.

MRS MASON: I don't understand what has happened here.

In the distance, BEN, in a huge patched frock coat and giant mortar board, processes into view...

In one hand he has a large gilded mirror raised into which he is gazing... With the other he drags a rope, leading a bound PREGNANT WOMAN who has a hessian sack over her head and a 'NonSpec' sign around her neck.

He sees MERT. He loses focus from his mirror... They stare at each other...

MRS MASON lifts her hand to wave. MERT pulls it down.

Then BEN turns and continues with his procession, dragging the pregnant woman out of view.

MRS MASON: The Special Zone is not what it was.

MERT: It is.

MRS MASON: So

MERT: Quiet

MRS MASON: I thought I should enjoy some peace but

MERT: No.

MRS MASON: No! You are right.

MERT: I know I am very right. This is worse than the Ghetto.

MRS MASON looks at MERT and cannot help smiling.

*And then they begin to laugh at the whole hopeless horror of it all...
They laugh so hard that tears begin to fall.*

The piped music dips in volume

OFFICIAL VOICE: *(Off.)* You are making an improper use of
moisture.

MERT and MRS MASON cannot stop.

OFFICIAL VOICE: *(Off.)* You are warned. I am now slating...
Drop your pies, kneel and put your hands in the air.

MRS MASON: This is a Mr Ackroyd pie! I will do no such
thing!

MERT: And I am never kneeling.

There is the SOUND of the heavy loading of rifles.

MRS MASON: Mert! Darling! It is '*I* will never kneel'.

MERT: But I would. I would kneel for you Mrs M. Do you
wish that?

OFFICIAL VOICE: *(Off.)* You are slated. You are NonSpec...
Kneel Now!

MRS MASON: No darling. We shall stand.

*MERT takes MRS MASON's hand as THE SOUND of a volley of
shots ring out.*

MERT and MRS MASON, are flung to the floor... A huge pool of blood slowly spreads, surrounding them...

TWO GUARDS appear. They pick the dropped pies out of the blood, place them in their pockets then drag the bodies of MERT and MRS MASON off stage.

THE END